THE OWL THAT FELL FROM THE SKY

ABOUT THE AUTHOR

Brian Gill is the curator of land vertebrates—birds, reptiles, amphibians, and mammals other than whales—at Auckland Museum in New Zealand. His research has included studies of New Zealand cuckoos, song birds and extinct birds, and field surveys of reptiles and birds on Pacific islands. In 2010 he received the Ornithological Society of New Zealand's Robert Falla Memorial Award.

ALSO BY BRIAN GILL

New Zealand's Extinct Birds
with paintings by Paul Martinson

New Zealand Frogs and Reptiles
with Tony Whitaker

New Zealand's Unique Birds
with photographs by Geoff Moon

The owl that fell from the sky

stories of a museum curator

BRIAN GILL

AWA PRESS

First edition published in 2012 by Awa Press, Level One,
85 Victoria Street, Wellington, New Zealand.

Copyright © Brian Gill 2012

The right of Brian Gill to be identified as the author of this work
in terms of Section 96 of the Copyright Act 1994 is hereby asserted.

This book is sold subject to the condition that it shall not, by way of
trade or otherwise, be lent, resold, hired out or otherwise circulated
without the publisher's prior consent in any form of binding or cover
other than that in which it is published and without a similar condition
including this condition being imposed on the subsequent purchaser.

National Library of New Zealand Cataloguing-in-Publication Data
Gill, Brian (Brian James)
The owl that fell from the sky : stories of a museum curator / Brian Gill.
Includes index.
ISBN 978-1-877551-13-0
1. Gill, Brian (Brian James) 2. Auckland War Memorial Museum.
3. Museums—Curatorship—Anecdotes. 4. Museum curators—
Anecdotes. I. Title.
069.099324—dc 23

Front cover photograph by Valerie Shaff, Getty Images
Book design by Pieta Brenton
Typesetting by Tina Delceg
This book is typeset in Feijoa and Sabon
Printed by Everbest Printing Company Ltd, China

www.awapress.com

Produced with the assistance of

ARTS COUNCIL OF NEW ZEALAND TOI AOTEAROA

Contents

Introduction	1
The owl that fell from the sky	25
The Kaikoura moa egg	33
Jammit, the Ōkārito kiwi	43
Leo Cappel's albatross diorama	51
Willie Cheeseman's reef heron	57
The Duke of Genoa's black-thighed falconet	65
A long-remembered ovenbird nest	75
Rajah, the elephant	85
Mr Mackechnie's Arctic group	93
Charles Adams' orang-utan	99
The mystery of the banjo frogs	107
Captain Cook's tortoise	113
Turtle bones	119
The Aitutaki house geckos	127
Foster Bay's sea snake	135
List of Illustrations	140
Registration numbers	142
Further reading	143
Acknowledgements	145
Index	146

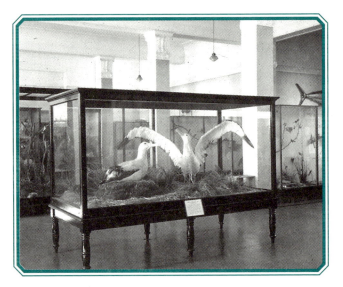

Boy, that museum was full of glass cases. There were even more upstairs, with deer inside them drinking at water holes, and birds flying south for the winter. ... The best thing, though, in that museum was that everything always stayed right where it was.

J. D. SALINGER
The Catcher in the Rye

Introduction

Rock pools at the end of St Clair Beach in the southern city of Dunedin are fixed in my childhood memories. During a weekend family stroll, I was fossicking among the pools when a small fish leapt out of the water and stranded on the rocks at my feet. It was shaped a bit like a tropical angelfish but with a long tubular mouth. I took it home and my father, with a vague idea of what to do with the now dead fish, put it into methylated spirits in a red Elastoplast tin.

After school one day he took me—and the fish—to Otago Museum. I already knew the museum galleries from family visits but this occasion was different. We were shown through doors at the back into a large dim office lined with old books and dotted with specimen jars. I sat on the edge of a chair while a curator, who seemed very old but was probably not yet forty, closely examined the fish. Finally, he declared that it was a very interesting find, and I think he asked to have it for the collection.

Most natural history curators periodically meet children and their parents to examine an unidentified object and

suggest what it might be. The curator's office, workroom and kind words can make a big impression on young minds. I hope that, in my turn, I have repaid the experience I was graciously given by the curator at Otago Museum in the early 1960s. I have surely had a small impact on children visiting Auckland Museum, if only on the day I emerged from a back door into the Bird Hall wearing a white lab coat and pushing a trolleyload of stuffed birds. A small boy gasped and tugged at his mother's skirt. "Look, Mum," he said, "it's a scientist!"

༄

You find a strangely shaped bone in your takeaway meal and have unsettling thoughts. What exactly have you been eating? You take the bone to your local health authorities and they refer it to the local natural history museum for a definitive answer. The expert staff who handle the museum's reference collections of real bones quickly and accurately determine the nature of the bone.

This is a small example of why natural history museums are assets to the cities that have them. In such museums, collections of natural history specimens gradually build into a vast and immensely useful resource. Certain key specimens, perfectly preserved or beautifully set up, are exhibited in public galleries to educate and inspire visitors. Most, though, serve a more mundane role. Stored in backroom "libraries", they are, by arrangement, accessible to people who are pursuing research projects, or seeking specialised identification of unknown material.

A great strength of the collections in natural history museums is that they help us understand life on Earth in all its exuberant diversity—and understanding nature is a crucial step towards protecting it. These museums are part of a worldwide project, begun more than two centuries ago, to fully identify, describe, name and catalogue the biodiversity of our wonderful planet. So far, just under two million plants and animals have been described and named. The problem is there may be another six to fifteen million species—estimates vary wildly—waiting to be recognised and described.

The specialists, or taxonomists, trained to do this work—many employed in natural history museums—number only about five thousand around the world. Although the task is overwhelming, financial support has steadily declined in the last thirty to forty years as the science of taxonomy has suffered the stigma of being thought old-fashioned and unimaginative.

The Nobel Prize-winning physicist Ernest Rutherford, engaging in a touch of hyperbole, once dismissed all sciences other than physics as stamp-collecting. The truth is entirely different. Specimens in a natural history museum may be superficially arranged like a stamp collection, but as the British palaeontologist Richard Fortey has said, "The catalogue [generated by taxonomists] happens to be the description of what four billion years of life's history has achieved, and its contents are a measure of the health of the planet. Isn't that enough?"

It is in the strategic interest of every country to know what plants and animals inhabit its territory. The local

flora and fauna may be a rich source of naturally occurring compounds and materials of pharmaceutical and other economic interest. A revolutionary new drug can come from as common a substance as tree bark or a marine sponge. Scientists can recognise and tackle a new pest affecting agriculture, horticulture, forestry or aquaculture only if they know what organisms are already present. On top of this, high-profile species and their local habitats can attract tourists and boost the local economy.

This week I read a science news story about a protein under study in the three-toed skink *Saiphos equalis*, an Australian lizard. The protein promotes the growth of blood vessels, which help form a placenta-like structure to nourish the lizard's growing embryos and enable the retention of eggs and birth of live young. Somewhat surprisingly, this has implications for cancer in humans. Malignant tumours grow by disrupting molecular machinery for the growth of blood vessels. There is a theory that this machinery originally evolved to allow pregnancy as egg-layers evolved into live-bearers. Cancer may have been absent in our egg-laying ancestors, and the mechanics of the simple form of pregnancy in the skink is of medical interest.

It is essential for researchers in the project to know what species of lizard they are studying, and hence how it relates taxonomically to other animals. They must be confident that their study animals are not a confusing mix of similar species that could differ slightly in their proteins and blur the results. This is the underlying and enduring relevance of taxonomy in biology, and part of the vital importance of natural history collections in the modern world.

The natural history museum has its origins in seventeenth- and eighteenth-century Europe, where "cabinets of curiosities" were accumulated by aristocrats and rich merchants. Many of the treasured specimens were brought by sailors and seafarers returning from their travels to newly acquired trading posts and colonial territories. In England, one of the earliest notable cabinets was the Musaeum Tradescantianum, or Tradescant's Ark, belonging to John Tradescant the Elder, in whose honour the plant *Tradescantia* is named. Musaeum Tradescantianum opened to the public in Lambeth, South London, in 1626, with such wonders as a mermaid's hand, a piece of the True Cross, and blood that had rained down on the Isle of Wight. It was an instant success.

Visitors to private collections such as this were enchanted. In 1772 the Reverend William Sheffield, after he had visited Joseph Banks' house in London, wrote to a friend: "His house is a perfect museum; every room contains an inestimable treasure. I passed almost a whole day here in the utmost astonishment, could scarce credit my senses. ... [The third apartment] contains an almost numberless collection of animals; quadrupeds, birds, fish, amphibia, reptiles, insects and vermes, preserved in spirits…"

A member of the landed gentry, Ashton Lever, established a private museum at Alkrington Hall, his home near Manchester. The collection grew so large he opened second premises in London and charged admission. By 1784 his collection contained 28,000 items, including specimens from

Captain James Cook's voyages of discovery. However, the private museums that shared their splendours with the public seldom prioritised what is today called "client-focus". When his museum was in full swing, Lever inserted a notice in the newspapers: "This is to inform the Publick that being tired out with the insolence of the common People, who I have hitherto indulged with a sight of my museum (at Alkrington) I am now come to the resolution of refusing admittance to the lower class except they come provided with a ticket from some Gentleman or Lady of my acquaintance."

Uncertainty always hung over the long-term survival of these private museums: a change in circumstances could all too easily threaten the continuity of the collections. In due course Lever, then Sir Ashton, found himself short of money. He held a lottery with 36,000 tickets at a guinea each, the prize being his entire museum. At the draw, only 8,000 tickets had sold but the winning one was among them. Soon after the lottery Sir Ashton was too successful drowning his sorrows and died at the Bull's Head Inn.

It was a great innovation when a wealthy physician, Sir Hans Sloane, bequeathed his large private collection— including natural history items—to the British public in return for a payment to his heirs. The necessary funds were raised by a lottery, and one of the world's first major publicly owned museums—the British Museum—was established in 1753, comprising both a collection and a building, Montagu House in Bloomsbury, to house it. In 1793 France's first republican government created another great national museum when it opened the Palais du Louvre, one-time residence of Louis XIV, the Sun King, to ordinary citizens,

who could view the collections of confiscated church and royal property. The Paris natural history museum, Muséum national d'Histoire naturelle, was formed as a public institution in the same year.

Like hospitals, postage stamps, fire brigades and sliced bread, public museums were such a good idea they caught on everywhere. It is estimated there are now some 30,000 collecting institutions in the United States alone; together they hold around 4,800 million individual collection items. The total number of biological specimens in museums around the world has been put at between 2,500 million and 3,000 million. There are about seventy million specimens, including a million birds' eggs, just in London's Natural History Museum.

∞

Collections lie at the heart of the natural history museum. These collections are like libraries, but instead of books there are animal and plant specimens "prepared"—preserved—for long-term storage. Different sorts of plants and animals can be prepared in multiple ways, and for each species a museum needs examples of all of them.

The form of preservation of birds that everyone understands from museum displays is the stuffed specimen, or "mount", which a taxidermist has set in a realistic pose—wires inserted in the wings and legs allow for exact positioning—and with glass eyes. More important for research are the study-skins. These require the same skilled taxidermy but for easy storage and examination they are set

out straight, like a human body laid in a coffin. No glass eyes or positioning wires are needed, and for support and ease of handling there is often a central wooden rod, which emerges from the underside at the base of the tail.

Sets of loose bones are essential for identification work, and bones of an individual joined together as an articulated skeleton are useful for exhibitions. Birds preserved whole in alcohol are needed for some purposes, and this is the standard way of preserving reptiles and amphibians. Birds' nests are also collected, as are birds' eggs with their contents blown out through a single hole in the side. And there may be spread wings, which are of special interest to bird artists and illustrators, and feather-sheets to aid in identifying individual feathers.

While a small proportion of a museum's natural history specimens appear in exhibitions, most remain in storage as reference material, to help with identification of unknown samples and to be examined, measured and recorded by students and scholars, who will use the data in all kinds of biological research studies. Like books on a library shelf, the specimens are arranged by species, like with like, and in a known and predictable taxonomic order, for easy retrieval. There is usually a catalogue or index, often electronic, from which to find specimens of a particular kind or from a particular place or region. Every bird must be marked with a registration number, which links to a record of where, when and by whom it was collected. For the specimens to retain their scientific and historic worth these numbers and background details must be preserved decade after decade.

Fully documented natural history specimens are called "voucher specimens". Each provides a documentary record of biological occurrence and distribution that is superior to a mere literature record because the specimen is present and its identity can be checked and reconsidered in the future. As natural history collections grow they become massive directories of the animals and plants that have lived in different areas at different times, and may hold the key to how the characteristics and distributions of species have varied with place and changed with time.

Most researchers who visit collections of vertebrates—animals with backbones—aim to record standard measurements of a particular species. These are usually analysed for differences between the sexes, or between populations from different regions. Also looked at will be shape (of bones, for example), number (feathers, scales, et cetera) and colour or pattern (feathers, eggs, et cetera). Recently there has been a surge of interest in using spectrophotometers—devices that measure light intensity and absorption—to measure colour attributes of birds' plumage and eggshells for studies of ecology and evolution.

Increasingly, researchers request destructive sampling to pursue biomolecular studies. Curators often grant these requests, but with strict limits and controls. Such studies have looked at heavy-metal contamination—for example, the incidence of mercury in the feathers of oceanic seabirds—and have carbon-dated fossil bones and assessed stable isotopes for the light they cast on ecological attributes such as diet. However, most destructive sampling is for analysis of DNA, which gives insights into the taxonomic identity,

relatedness and sex of individuals, and the genetic variability of populations.

New Zealand was originally home to about 400 species of birds. A bird has nearly 130 different bones in its body, so for any single unidentified bird bone in New Zealand there are around 50,000 possibilities. A comprehensive collection of bird bones is, therefore, essential for identification: no book or website can yet substitute effectively for the real things. A museum's bone collection, time-consuming and labour-intensive to acquire and prepare, stands ready to help police, customs, agricultural quarantine authorities and health agencies with enquiries relating to poaching, smuggling, food complaints and other forensic issues. Bone collections are also a major resource for research projects in zoology, palaeontology and archaeology.

Similar research and identification take place daily in the diverse collections of natural history museums. The stories in this book are about birds, mammals, reptiles and amphibians. Other major biological groups covered by most large museum collections are higher plants, lower plants (for example, mosses, lichens, seaweeds), whales, fishes, crustaceans, insects, spiders, myriapods (centipedes and millepedes), molluscs, and polychaetes, a major group of worms.

Many other less well-known groups of organisms, including sponges, bryozoans (seaweed-like animals), coelenterates (for example, jellyfish), brachiopods (lampshells), echinoderms (for example, starfish) and tunicates (sea-squirts), are also represented, as are rocks, minerals and fossils.

Nature conservation requires a clear understanding of biodiversity. Properly documenting the world's biodiversity needs large museum collections of voucher specimens, yet some nature-lovers recoil from, in particular, museum bird collections, assuming they represent a shameful carnage of birds. In fact, animals killed for museums are usually a drop in the bucket compared to natural attrition. It is estimated that around the world more than a million birds die every day in collisions with cars, and another million are killed by household cats. In the United States alone as many as 100 million birds die each year by flying into windows. Such losses are usually easily made up by birds' prolific breeding. It has been calculated that the birds currently collected for all North American natural history museums combined are equivalent to the number that would be killed in the same period by just fifteen medium-sized bird-eating hawks. Increasingly, too, many museums get some or all of their new bird specimens by salvage from those killed accidentally.

When confronted by dozens of study-skins of a common bird on a tray, a person will often ask why so many specimens are needed. The answer lies in the variability of individuals with age, stage of growth, sex, colour-form, season, geographical location, decade, century, and also in random individual ways. A biologist cannot characterise a species by examination of just a few birds: to calculate average measurements and look for tendencies and trends they need representative series of specimens. In this way,

natural history collections underpin biology, and support studies of evolution, speciation (the formation of species), biogeography (the distribution of organisms), morphology (the study of shape and form), and conservation.

Much collection-building by natural history curators is general, rather than directed towards any immediate need. As long as the collections are representative, the curators have faith that such specimens will prove indispensable to future users, often in ways we cannot now imagine. Curators a century ago had no idea how useful some of their specimens would be when later researchers subjected them to electron microscopy, X-rays, CT scans, and analyses of isotopes and DNA.

In the 1800s, as part of its general collecting, the British Museum seized all opportunities to acquire specimens of *Sphenodon punctatus*, a reptile found only in New Zealand. In 1842 a curator, John Edward Gray, used some of the earliest material to describe and name the animal, assuming from its appearance that it was a kind of lizard. A subsequent curator, Albert Günther, who joined the museum in 1857, re-examined the same specimens and made his most important scientific discovery—that the tuatara, as Māori called it, was not a lizard at all, but the lone survivor of an order of reptiles that had died out everywhere else in the world at least sixty million years ago.

Using other specimens, one of which is now at Canterbury Museum in Christchurch, the ornithologist Walter Buller in 1877 described the distinctive tuatara from North Brother Island in Cook Strait as a new species and named it *S. guntheri* in Günther's honour. In the 1980s the London specimens

contributed to a study of the musculature of primitive reptiles, and helped an investigation that reconfirmed there are indeed two species of tuatara. In 2000, Richard Jakob-Hoff, a veterinarian at Auckland Zoo, familiarised himself with tuatara jawbones in Auckland Museum's collection before operating on a captive tuatara with a jaw abscess. These examples show how taxpayers, ratepayers and donors who made possible the acquisition and storage of tuatara specimens in London, Christchurch and Auckland over many decades were supporting science for present and future generations.

As important as collections are, their usefulness would be severely limited without staff with the specialised knowledge and experience to understand and interpret the specimens. Continuity in curatorial care is important, so that when a curator leaves the knowledge about his or her collection can be readily taken up by a successor. There are few museum circumstances more tragic than a once active collection no longer having a curator.

Curators have three main roles. First, we develop, record, maintain and manage the collections, directly or indirectly. Second, we make the collections and associated documentation accessible to the public by putting forward objects and information for exhibitions and displays, helping visiting researchers, answering public enquiries, and participating in the museum's educational and outreach programmes.

Third, we conduct our own research. Most educational ivities—including secondary schooling, undergraduate ...tiary teaching, non-fiction book publishing, broadcasting of television documentaries, and the mounting of museum displays—largely involve the communication and recycling of existing knowledge. Museums, through the research of their curators and visiting scholars, are in that select group of scholarly institutions that generate new knowledge.

This important principle was touched on in the will of the British philanthropist James Smithson, whose bequest to found an establishment at Washington, D.C. led to the formation of the Smithsonian Institution. The Smithsonian was intended to not just communicate information, but generate new insights through research on its collections and by its curators. In the words of Smithson's will, it was to be an establishment "for the increase and diffusion of knowledge among men".

Curators often serve long periods with the same collection as they delve deeper into its delights and mysteries. At Auckland Museum, Thomas Cheeseman, the director and botanist, served forty-nine years and his successor Gilbert Archey, director, zoologist and ethnologist, forty. In my time, at least four curatorial colleagues have left after serving twenty to thirty years. The legacies of these long careers are the curators' numerous publications, the exhibitions to which they have contributed, the public talks and media interviews they have given, and the arrangement, growth and recording of the museum collections themselves.

Ron Scarlett (1911–2002) spent some fifty years at Canterbury Museum in Christchurch, continuing in a

voluntary capacity after his retirement until he was ninety. However, his long academic career had a shaky start. An opportunity to attend university presented itself when Ron was twenty-six. He cycled from his home on the West Coast across the Southern Alps to Christchurch to enrol for a Bachelor of Arts, only to have his studies interrupted by the Second World War. He was unsuccessful in volunteering for ambulance duty and was interned at Hautu Detention Camp for conscientious objectors. In 1952 he got work at Canterbury Museum, where he became the osteologist, an anatomist skilled in the structure and function of bones. His work identifying bird bones over many decades greatly helped archaeologists whose digs were uncovering new details of Māori settlement of New Zealand.

Perhaps New Zealand's best-known bird curator, and the leading ornithologist of his generation, was Robert Alexander Falla (1901–79). As a young man, Falla secured a position as assistant zoologist on Douglas Mawson's British, Australian, New Zealand Antarctic Research Expedition during the summers of 1929 to 1930 and 1930 to 1931. He was then appointed ornithologist at Auckland Museum, one of that institution's first specialist curators. In 1937 he became director at Canterbury Museum, and in 1947 moved to Wellington to take up the directorship of the Dominion Museum. Falla popularised ornithology through frequent public lectures and radio broadcasts, and was a firm advocate for conservation. He was also renowned for his puns, quipping after a field trip that had failed to find spotless crakes at a likely location that at least they had seen some beautiful crakeless spots.

The bird collections of the National Museum of New Zealand were greatly enhanced and professionalised by the skill and dedication of Fred Kinsky (1911–99), who joined the museum as a clerk in 1955 and retired as curator of birds in 1976. Kinsky was a Czech aristocrat who became a political refugee and immigrated to New Zealand after the communist takeover of his country in 1948. He was by habit a night person, frequently working at the museum or at home into the early hours of the morning. He seldom arrived at work before ten in the morning, which he referred to as dawn. For a time, a new director attempted to get him to start work at eight-thirty but the results were unproductive and he was allowed to revert to his natural rhythm.

One of the world's great bird curators was Ernst Mayr (1904–2005). A German with a passion for natural history, Mayr started his museum career in 1926 as an assistant at the natural history museum in Berlin. Success with field work in New Guinea and the Solomon Islands led to his appointment as a curator at the American Museum of Natural History in New York in 1931, and later at Harvard University's Museum of Comparative Zoology. His work with birds collected from islands across the Pacific by the Whitney South Sea Expedition led to new insights into birds' evolution: he was at the forefront of the twentieth-century reinterpretation and refinement of Darwin's original ideas.

Surely one of the most intrepid museum ornithologists was Tom Harrisson, curator of the Sarawak Museum from 1947, and a keen ethnologist and archaeologist. Towards the end of the Second World War, Harrisson was parachuted into Borneo as part of a reconnaissance unit. There he helped

rescue downed British airmen. He also organised local dayak tribes against the occupying Japanese—and again in the early 1960s against communist insurgents in the Brunei Revolt. In 2011, collecting data from skins of long-tailed cuckoos in The Natural History Museum's collection in Britain, I handled a cuckoo that Harrisson had collected in Vanuatu in 1934.

War service interrupted the directorship of Auckland Museum by Gilbert Archey (1890–1974). Archey had already served in France during the First World War, but he joined the fray again as a lieutenant colonel in the British Military Administration in Malaya until 1947. Archey amassed much of Auckland Museum's large moa-bone collection and published a major study of moa in 1941, for which he was awarded a science doctorate by the University of New Zealand.

I sometimes need to consult a particular set of old books. Their dull brown spines and shabby appearance are deceptive: at the end of each volume there are exquisite hand-coloured lithographs of birds, and the current monetary value of the set is in the six figures. This twenty-seven-volume *Catalogue of the Birds in the British Museum* was produced between 1874 and 1898 and is still in use for bird nomenclature. A major contributor was Richard Bowdler Sharpe (1847–1909), who was for thirty-seven years curator of birds at the British Museum (Natural History). Sharpe had ten daughters and several worked for publishers, adding colours by hand

to lithographs, perhaps to some of those that illustrated their father's prestigious books. The New Zealand fernbirds, small brown swampland songbirds, are in the genus *Bowdleria* named in honour of Sharpe. Elsewhere in the South Pacific he is remembered in the name of the Samoan triller *Lalage sharpei*.

∞

Among the personality traits of the successful curator is the passion to collect. The desire to extend collections, fill in gaps and make holdings bigger, better and more complete is an underlying requirement of the job. But such collecting can get out of hand. Martin Hinton (1883–1961), a mammalogist at the British Museum (Natural History), was described by contemporaries as having the innate habits of a squirrel. He smoked an ounce of tobacco a day from the age of seventeen and never threw away a tobacco tin. After he died, more than 10,000 tobacco tins were removed from his rooms, as was more than a tonne of paper, including receipts, chequebook stubs, used envelopes and notices, all mixed up and some going back over sixty years.

Squirrel-like habits in a mammalogist show the danger curators run of becoming like the things they study. Dave Simmons, former ethnologist at Auckland Museum, once told me that as he grew older and his face more lined, his wife accused him of looking more and more like a Māori carving. Could it be that I myself sometimes chatter too quickly and move too jerkily, like a bird? If so, I hope a friend will tell me.

Improving and developing collections for the long haul requires tenacity, but determination was perhaps a little misdirected in George Albert Boulenger (1858–1937), an expert on reptiles and amphibians at the British Museum (Natural History). Boulenger was so angered and saddened by the German invasion of his native Belgium that he refused to read any German publications issued after 1914.

This famed herpetologist published a nine-volume catalogue of the amphibians and reptiles in the museum's collection of nearly 8,500 species. He holds the record for having described more currently recognised species of reptiles than anyone else—some 570. He described and named at least three New Zealand skinks that still bear his original names; among them is the endangered chevron skink *Oligosoma homalonotum*.

Peter Whitehead (1930–1992), an ichthyologist at the British Museum (Natural History), had interests beyond his immediate collection of fishes. His career coincided with an era when administrative tasks previously done by senior scientists were increasingly taken over by a new breed of museum managers. For many years Whitehead worked on the draft of a satirical novel about events behind the scenes in the running of the museum. He is said to have abandoned the novel when actual events at the museum became more ludicrous than those he had invented.

Chronic underfunding has been an enduring problem for many natural history collections. In recent decades financial

crises have seen closures of some collecting institutions, particularly small ones such as university museums. Bigger museums have also suffered. In the early 1990s about a sixth of the scientific staff at the Natural History Museum in London was axed. Such disruptions, combined with the ageing workforce of taxonomists and the failure of universities and museums to train and employ enough new ones, mean we may never accomplish the fundamental cataloguing needed for a proper understanding of the world's biodiversity.

Yet natural history museums, and natural history galleries within general museums, remain enormously alluring to the public. Sharks, dinosaurs, giant squids, spiders and other venomous creatures, fossils and mounted birds and mammals seem of perennial interest. No large general museum in New Zealand would be complete without displays of moa and kiwi. Similarly, most other countries have popular and emblematic animals that their museums must display.

Today there are about 500,000 bird specimens (study-skins and all other categories) in Australian and New Zealand museums, and at least four million bird study-skins in the museums of Europe. Linked together—in principle, if not physically—collections of different museums form a major collective asset for biological research. Rapid progress is being made in digitising the collecting details and images of natural history specimens around the world, with the ultimate aim of making all this material accessible on the worldwide web.

Already hundreds of research projects have used the bird specimens in New Zealand museums. Most significantly,

the collections were studied by researchers to record measurements and write plumage descriptions for the *Handbook of Australian, New Zealand and Antarctic Birds*, researched over twenty years and published in seven volumes from 1990 to 2006. This joint venture of the Royal Australasian Ornithologists' Union and Oxford University Press summarises all that is known about the birds of the region. It is our most important bird book in a hundred years.

The bigger a museum's natural history collections and the more numerous its scientific experts, the greater are its opportunities to serve humanity. This point is illustrated by two examples from the Natural History Museum, London. The first involves poisonous snakes. Doctors in north-east Nigeria used to treat people bitten by carpet vipers with a serum produced using local snakes. When this supply ceased, they changed to antitoxin from Iranian carpet vipers but many snake-bite victims died. Scientists were able to turn to the museum's collection to examine hundreds of specimens of carpet vipers collected from Africa to Sri Lanka over one hundred years. They quickly (and cheaply) showed that Iranian and Nigerian carpet vipers were different species. The museum collections provided a rational explanation for the failure of the serum, and the basis from which to seek a solution.

The second example concerns an entomology curator, Martin Hall. Hall, who had specialised knowledge of flies with flesh-eating maggots, worked among the roughly twenty-eight million insect specimens held at the museum. In Libya in the late 1980s, he discovered and identified an accidentally established population of the New World

screwworm fly. Realising this damaging insect could spread across Africa and destroy cattle and wildlife, Hall raised maggots in his hotel room to help convince local officials to take action. The infestation was eventually eradicated in an expensive United Nations programme that involved the release of millions of sterile male flies reared in a laboratory. The museum had been instrumental in helping save Africa from a potential plague.

∞

Museum bones have recently solved the mystery of New Zealand's large extinct flightless birds, the giant moa. For decades it was thought there were three species, large, medium-sized and small, all present in both North and South Islands. They were told apart not by unique characters, such as different bone shapes, but by average size. This was always a concern, for how could you identify a bone that fell in the region of overlap?

To help sort out the taxonomy of moa, scientists turned to DNA. They developed ever better techniques to recover ancient DNA fragments from old moa bones, mostly those in the collections of the four main New Zealand museums that had been collecting moa bones for over a century. The DNA results, published in 2003 in the British science journal *Nature*, showed there were two species of giant moa, not three, and instead of overlapping in distribution they occupied mutually exclusive areas—one in the North Island and one in the South. The DNA also permitted sexing of the giant moa bones. It transpired that the larger bones

were from females, and the size differences were extreme, with females two to three times bigger than males. Scientists had been misinterpreting giant moa bones for 150 years.

∽

Every natural history museum around the world has its own store of fabulous tales. These stories—of which a selection from my own experience make up this book—show how developing, curating and understanding collections can provide richness and endless fascination. Even more importantly, museum collections help us understand, and so protect, the vital biodiversity on which our existence depends.

The owl that fell from the sky

Towards the end of 1955, a man and his young son were driving along a road a couple of kilometres from the mouth of the Haast River in south Westland, a remote and isolated part of the South Island of New Zealand. Suddenly, ahead of them, a bird with a rat in its talons rose up from the road and they couldn't avoid hitting it. The pale bird was so unusual that they kept the body for a few days to show people. Nobody in the small town of Okura where they lived, not even the schoolmaster, had seen its like.

A couple of years after the death of the pale bird, the boy, then fourteen, visited Wellington with a friend and the two of them went to the Dominion Museum to give further details to Dr Falla. Bob Falla—later Sir Robert—was the museum's director, and New Zealand's best-known ornithologist through his newspaper articles and radio programmes. The out-of-town visitors were no doubt a little nervous walking up the hill to the imposing museum building, where they were ushered into the staff-only precinct, but the legendary Dr Falla, tall and lanky, would soon have put them at ease with his broad smile and pleasant manner.

In a back room where the museum's bird reference collections were stored, Falla first showed them some study-skins of the morepork, the common New Zealand owl, which the boy knew. Then came specimens of the larger laughing owl, one of New Zealand's many extinct birds. Finally, he produced a selection of foreign owls, and from among them the boy did not hesitate to pick out the specimen of a barn owl.

Common barn owls—*Tyto alba*—are one of the world's most widely distributed land-birds, living on all continents except Antarctica. In most parts of the world, people grow up knowing these pale ghostly owls but not in New Zealand: it is one of the few places from which they are absent. The 1955 Haast River bird was only the second ever recorded: one had been shot at Barrytown in north Westland in 1947.

Birds fairly regularly straggle from Australia to New Zealand, carried across the Tasman Sea by the prevailing westerly winds, so it was not surprising that these owls—assumed to be Australian—fetched up on the West Coast. In 1960 a third would be found dead in a disused house at Runanga, also in north Westland.

An unexpected telephone call or visitor, heralding what may be a rare or unusual find, adds spice to the natural history curator's day. Amid routine interruptions there will sooner or later, and quite at random, be an event to write home about.

In March 1983 Graham Turbott, an ornithologist and the former director of Auckland Museum, rang me to say that a schoolgirl from Papatoetoe in south Auckland had found a strange white bird. She had been walking through the grounds of her school when she had seen the bird huddled on grass under a tree. She had thought it was dead, but then it flew off weakly. She caught it and took it home. However, despite care and attention, the unfortunate bird died in the night.

Graham Turbott brought the corpse to the museum, and when we unwrapped the package on the workbench it was immediately clear it was some sort of barn owl. I had never seen a fresh one before, but obvious at once were the soft pale plumage, the facial feathers arranged in a characteristic large heart-shaped disc, the long legs with talons, and the small, sharp beak. A creature superbly adapted for night-time hunting, with acute hearing and silent flight, it was also beautiful, with feathers of white, grey and ochre, many of them barred or spotted.

From the museum library upstairs we brought down bird books from around the world and studied their photographs and drawings of owls. From the museum's reference collection of bird specimens we pulled out the handful of study-skins of tytonid, or barn, owls. Museums need natural history collections from their own country and region, but representative examples of key foreign animal groups have their uses as well.

We took standard measurements of the dead owl, including the length of the wing, tail and beak, and soon confirmed from its size, and the colour and pattern of its

plumage, that it was the widespread common barn owl and not one of the several other species of barn owl that live in Australia. The common barn owl also lives on many of the island groups in the south-west Pacific just north of New Zealand, so the bird's geographic origin was uncertain.

⁌

This was, then, the fourth record of a barn owl in New Zealand. The bird may have flown across from Australia, or from a Pacific island, although this was less likely. Or it could have been smuggled in as a captive and subsequently escaped or been released. However, the girl's father had mentioned a third possibility. The suburb where the bird had been found was close to Auckland International Airport and, depending on the wind direction, lay immediately under the flight path of jets as they came in to land.

The museum's reference collection was not extensive enough to include representative samples of barn owls from the Australian and Pacific island populations against which we could compare the mystery bird and come to a conclusion about its place of origin. The differences between these populations are not dramatic anyway, and the measurements we took, and then compared to published dimensions, were in the region of overlap and hence inconclusive.

I now made a post-mortem examination. By locating the gonads inside the body cavity, I discovered the owl was a male. There was considerable fat around its stomach and large intestine, and a large mound of fat lay just beneath

the belly wall. Inside the intestine, along its length, there was merely a paste-like residue of digested food remains. However, the gizzard, or muscular part of the stomach, contained a dark ball of matter. When I teased this out, I discovered a quantity of hair and small bones that proved to be the remains of a house mouse. This was no help to establishing what country the bird had come from, since the introduced European house mouse is found in Australia and most Pacific islands.

In the gizzard, however, I also found a tiny insect head about one millimetre across. I consulted the museum entomologist, Keith Wise, who said this was probably from an ant.

On Wise's advice, I sent the tiny specimen to a curator at the Australian National Insect Collection in Canberra, who was able to identify it as belonging to a species of ant unique to Australia and common in grassy areas in and around cities of the south-east. The ant, presumably eaten accidentally while the owl was swallowing the mouse, pinned down the bird's geographic origin.

We next approached the New Zealand Meteorological Service for information on wind strength and direction in the days leading up to the owl's discovery. Winds had been strongly from the west and the conditions suggested that a bird at low altitude could have flown to Auckland from south-east Australia in under two days. But even after such a relatively short flight from Australia a bird would be

expected to be lean, with an empty stomach, empty intestines, and little visible fat in its abdominal cavity. Given the fat condition of the owl, and the presence of food in its gut, it seemed far more likely that it had been foraging around an Australian airport, had roosted in the undercarriage bay of a large jet as dawn broke, and had become trapped there when the plane took off.

Several types of Australian birds survive cold nights in the Outback by entering a physiological state of torpor: their metabolism slows until sunrise and the return of warmer daytime temperatures. The extreme cold in the jet's unpressurised undercarriage bay may have forced the owl into some sort of torpid state and come close to killing it outright. When the wheels went down three hours later over Papatoetoe, the owl fell out and came to ground fatally sickened.

A taxidermist transformed the owl's body into a permanent dry study-skin by skinning it, meticulously cleaning and defatting the inside of the skin and the remaining attached bones (skull, and outermost wing and leg bones), replacing the separated body with an artificial form of the same shape and size, and sewing the skin back together along the incision lines. After drying and labelling it joined 5,000 other bird skins in Auckland Museum's collection, a testament to the important role of the public in reporting unusual finds.

∞

As a postscript to this story, in April 2008 a pair of barn owls were found breeding in farmland near Kaitaia in New

Zealand's far north. The birds were thought to be unassisted vagrants, most likely from Australia. If a population establishes, it will represent the barn owl's colonisation of one of its last unoccupied corners of the world.

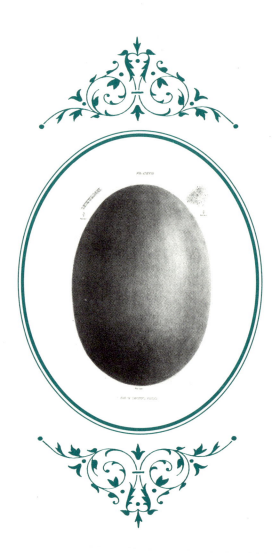

The Kaikoura moa egg

One day, probably some time between about 650 and 750 years ago—during the earliest period of Māori settlement of New Zealand—somebody collected an egg from a nest of a South Island giant moa, *Dinornis robustus*. Female giant moa, much larger than their mates, reached three metres tall in an upright standing position, making them the tallest known birds. (The ostrich, the tallest living bird, stands about 2.5 metres tall.) The largest giant moa are estimated to have weighed well over 240 kilograms and had neck vertebrae almost as big as a horse's, although other extinct birds—such as Australia's mihirungs, or giant runners, and Madagascar's elephant birds—were heavier.

The giant egg was not an easy thing to carry home: it was 240 millimetres long, 178 millimetres wide and weighed about four kilograms.

Exercising great skill and care, someone in the family group then used a stone drill-point, rotated by the string in a bow, to make a small round hole about ten millimetres in diameter at the pole of the moa egg's narrower end. What a meal was had: the contents of the giant egg were

the equivalent of at least five dozen hens' eggs. But the reason for the great care in opening the egg was that the empty perforated shell made a handy container with a liquid capacity of nearly four litres—a prized possession in a society with no pottery or glass.

Time passed and someone in the Kaikoura settlement where the egg had been collected, or received in trade, died. As was customary, a moa egg—in this case the egg in question— was placed in the grave beside the dead person. The body rested in peace for about 500 years with the egg beside it. Then one day in 1857 a workman was digging foundations for a building close to George Fyffe's house at the whaling station on the northern side of the Kaikoura Peninsula. At each swing of the pick into the ground the workman expected the usual resistance. Then he hit something hollow and stopped. Crouching down to scrape away loose soil and rubble he found that his pick had pierced a large egg and broken away one side of it. A human skeleton, a black stone adze head and other artefacts were at the same spot.

The Kaikoura egg was the first whole moa egg found following European settlement, and larger than any other egg found since. It was destined to excite much interest, to be displayed occasionally and be seen by thousands—and to embark on a risky journey around the world that would take one hundred years to complete.

༄

Given the fragility of birds' eggs, it is not surprising that only about thirty-six whole, or partially whole, moa eggs

are currently known. Many are imperfect, with a large section or several smaller sections missing. Others have been reconstructed, sometimes poorly and inaccurately, from broken fragments found together as an isolated group. Most are ivory-coloured, but there are a few green eggs that were laid by a species of moa in the South Island. Moa eggs range in size from 120 to 240 millimetres long. They have been found at about sixteen sites throughout the North and South Islands and nearly all the eggs are now in publicly owned museum collections, mostly in New Zealand. Thirteen are from archaeological sites—graves or middens—but most are from natural sites: alluvial deposits, mudflows, swamps, sand dunes and rock shelters.

George Fyffe kept the Kaikoura egg, with the Māori skull and adze head, in a candle box, until a visitor suggested it would be safer to keep the heavy stone adze head separately. By now the egg was attracting considerable attention. The ornithologist Walter Buller stated that it had been submitted to him for examination "soon after its exhumation". Charles Clifford, a politician and speaker of the House of Representatives, had accidentally broken off a bit while handling it.

By September 1864 the egg had been taken on the schooner *Ruby* to Wellington. There Fyffe allowed it to be displayed in the offices of Messrs. Bethune and Hunter, auctioneers and shipping agents. It was shown—damaged side down—in a box made of New Zealand wood, with a small drawer beneath to hold the broken fragments. From January 12 to May 6, 1865, Fyffe exhibited the egg in the same box at the New Zealand Exhibition in Dunedin,

where it was in the Wellington Court as exhibition item 220. This event was the first of the big exhibitions held in New Zealand to showcase the colony's natural resources and its agricultural and manufactured products. During its one hundred and two days it attracted more than 30,000 visitors.

The *Ravenscraig*, a fast sailing ship of 800 tonnes, was in Wellington Harbour in late May 1865 to collect cabin passengers and make up the last of its consignment of wool bound for Britain. On Queen's Birthday holiday all public offices closed, private businesses halted, and the ships in the harbour displayed their best bunting. At noon the *Ravenscraig* fired the royal salute. When the ship finally left Wellington on June 21, 1865, it carried not just wool and passengers but also the Kaikoura egg—sent, presumably by Fyffe, for sale in London.

∾

With Captain D.B. Inglis in command, the *Ravenscraig* headed east for Cape Horn. There were gales and on July 3 the ship encountered a tremendous sea that swept its deck and did much damage. On July 14, in the Southern Ocean near the Cape, the second officer James Faddie fell overboard and was drowned. Fortunately the Kaikoura egg survived, and after the ship called at Pernambuco in Brazil the egg arrived safely in London in the middle of October. It was said to have been insured for £2000.

On November 24 at two in the afternoon, after having been examined by the great comparative anatomist Richard

Owen, the egg was put up for auction at Stevens' Rooms, 38 King Street, Covent Garden. Owen's contribution to New Zealand's natural history had already been significant: in 1839 he had correctly deduced the presence of gigantic flightless birds in New Zealand from examination of a section of a thigh bone.

An ornithologist, George Dawson Rowley, bid 100 guineas for the egg but the vendor wanted £200. After negotiating for three years, Rowley finally acquired it for £100. Meanwhile George Fyffe had died after falling from a jetty at Kaikoura.

The egg was kept at Rowley's ornithological museum at Chichester House in Brighton's East Cliff. A large lithographed image was published in the third volume of Rowley's 1878 book *Ornithological Miscellany* and repeated in Richard Owen's *Memoirs on the Extinct Wingless Birds of New Zealand* the following year.

Large eggs are difficult objects to measure—I have used special forestry callipers made for measuring tree diameters at chest height. Contemporary newspaper accounts put the moa egg at between nine and ten inches long and seven inches wide. The nine and a half by seven inches (241 × 178 millimetres) of one newspaper story was fairly accurate. Owen's book confused matters by incorrectly stating that the egg was ten by seven and a half inches (254 × 191 millimetres).

George Dawson Rowley died in 1878. An obituary in *Nature* noted that "he sank in his fifty-seventh year, dying, by a singular coincidence, on the very same day as his father, who had long been an invalid".

In 1886 the fame of the Kaikoura egg was boosted by its display in the New Zealand Court of the spectacular Colonial and Indian Exhibition in London. The event showcased natural products, manufactures and local objects and curiosities from the territories of the British Empire to encourage trade among them and foster cultural ties. The exhibition catalogue listed the moa egg after a "Native Chief's Carved Wooden Mere" and before maps from the New Zealand Mines Department. The exhibitor was given as G.T. Rowley of Morcott Hall, Uppingham, so the egg was apparently still in the family's possession and in central England.

∽

The Kaikoura egg now disappeared from view for eighty years, until in 1966 Mr R.A. Pratt, a New Zealander resident in Surrey, wrote to the Dominion Museum on behalf of the egg's current owner to ascertain if the museum had any interest in it. Robert Falla, soon to retire as director of the museum, was in London on other matters and began negotiations.

The egg was in the possession of E.G. James of London, who had recently been left it in the will of a former neighbour, Captain Vivian Hewitt of Anglesey in Wales. Mr James was willing to sell the egg and keen for it to go to a New Zealand museum. The Dominion Museum paid the modest sum of £300, which was remitted through the Official Secretary at New Zealand House in London. For at least one night Falla had the egg in his room at the Regent Palace Hotel in Piccadilly Circus. An expert in the

palaeontology department of the British Museum (Natural History) then repaired and strengthened the egg for travel, and it seems to have been forwarded to Wellington by fragile air freight, the original wooden case and loose fragments coming later by sea.

In Wellington, the egg was given the accession number 1966/220 and displayed for a while in the museum's foyer as a new acquisition. Initially it was in the zoology collections, where it bore the fossil collection number S.965. Later it was transferred to the Māori collections as ME12748. A cast of the egg, provenance unknown, is held by the Smithsonian Institution in Washington, D.C.

Having survived chance rediscovery by pickaxe, a perilous sea voyage to Britain, an auction, sale, and subsequent chequered history, the Kaikoura egg was finally safe in public ownership, a treasure for Māori culture and New Zealand archaeology and one of New Zealand's greatest zoological gems.

Its travels, however, were not yet over. In 1983 it was lent to Canterbury Museum in Christchurch to complement a temporary exhibition of archaeological items excavated in the 1970s from the Fyffe site at Kaikoura, and on Queen's Birthday weekend in 1986 it returned to Kaikoura to be displayed briefly at the Kaikoura Museum, and at Fyffe House where it had been found.

∞

In the early 2000s I began a project to examine all known whole moa eggs in New Zealand museums and compile an

annotated list, giving measurements and other details. With much anticipation I contemplated seeing the Kaikoura egg at the Museum of New Zealand Te Papa Tongarewa—the successor to the Dominion Museum. Approval was withheld for seven months for cultural reasons but at last, in the new museum building on the Wellington waterfront, I was shown into a small room and came face-to-face with the legendary Kaikoura egg.

The egg was resting on an acid-free cushion. The outer surface was pale brown, with some marks and stains. It was sound in many areas, with clearly marked pores, but worn smooth elsewhere. Some pieces had been glued back along the broken edge but about forty percent of the egg was missing. The damage was a bonus as I was able to measure shell thickness at several points around the break using vernier callipers, an instrument that measures the internal and external dimensions of an object to a high degree of accuracy.

I also weighed the egg, and inspected its outer surface with a magnifying thread-counter to see the slit-like pores and record their maximum length.

The thickness of the egg's shell was a surprise: the largest moa egg might be expected to have the thickest shell, but in fact it was only 1.2 to 1.3 millimetres. The thickest known shell—at about 1.8 millimetres—is that of a smaller moa egg in Otago Museum; it was found at the Shag River Mouth archaeological site on the South Island's east coast, about 500 kilometres south of Kaikoura. This egg is likely to have belonged to the heavy-footed moa, whose stocky proportions are indicated by its Latin name, *Pachyornis*

elephantopus. It seems the tall, slender giant moa could get by with thinner eggshell than its shorter, dumpier heavy-footed relation.

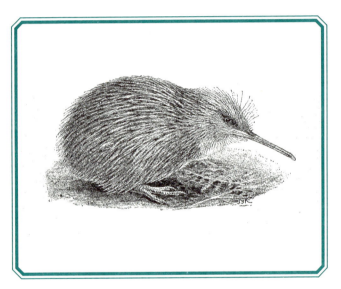

Jammit,
the Ōkārito kiwi

On the road to the tiny settlement of Ōkārito in Westland, a kiwi was hit and killed by a vehicle in August 2002. Its body was placed in a Department of Conservation freezer.

This bird had hatched in February 1999 in the South Ōkārito Forest. Later that year it had been caught and given a metal ring numbered R-55376. A DNA sample had disclosed that the kiwi was female and she had been given the name Jammit. She had been still immature and living with her parents when she died at the age of three and a half. Ōkārito kiwi are potentially long-lived, but in this sad case there was a small consolation, for Jammit was destined for a place in taxonomic history.

Kiwi are strange birds with a catalogue of remarkable features. The smallest of the ratites, a group of southern hemisphere birds that includes the emu and ostrich, they have unusual body proportions. Their legs, relatively large and muscular, make up about a third of their total body weight because their wings are only tiny vestiges. Their undeveloped flight muscles make their bodies cone-shaped—so much so that when the South Island brown kiwi was

described and named in 1813, on the basis of one preserved specimen that had reached Britain the previous year, some thought the authors of the description had been the victims of a hoax.

Adult kiwi weigh between one and three and a half kilograms, depending on the species and sex: the females are larger and about twenty percent heavier than the males. The bird's plumage is loose and hair-like. There are no prominent tail feathers, and the tiny wings are hidden in the body plumage. Around the face there are bristle-like feathers that transmit a sense of touch. The external nostrils open near the end of the long bill, which is slightly curved downwards, and this position of the nostrils is unique. Unlike most birds, kiwi have a good sense of smell. As they probe in the soil for food they snuffle noisily: they are forcefully exhaling to clear their nasal passages.

Kiwi inhabit forest and scrub from sea level to the subalpine zone and are predominantly nocturnal. They eat fruits, berries, insects, earthworms and other invertebrate animals they find on or near the forest floor or by probing in soft earth. They form a family of their own—the Apterygidae—that is found only in New Zealand. Their nests are in hollow logs, rock crevices or underground burrows that they excavate. The female produces one or two (very rarely three) eggs. The egg is very large relative to her weight and contains a high proportion of yolk. It is incubated for a long time—about eighty days—and the resulting chick is very advanced, in fact a miniature version of the adult.

Once found throughout the country in suitable habitats, kiwi have disappeared from many parts of New Zealand

and continue to decline everywhere on the mainland, except in places where there are interventions to reduce predation by rogue dogs, introduced stoats and other mammals. In the long term these birds may survive only in predator-controlled, specially fenced sanctuaries—known as "mainland islands"—and on predator-free offshore islands.

Until recently there were thought to be three species: brown kiwi (*Apteryx australis*), little spotted kiwi (*A. owenii*), and great spotted kiwi (*A. haastii*). The brown kiwi has brown plumage with darker lengthwise streaks, whereas the spotted kiwi have greyish plumage with paler crosswise streaks: from a distance they appear vaguely spotted.

In the last two decades, molecular biology has revolutionised taxonomy and classification—the process of defining boundaries between species and grouping the species in logical ways. The classification of birds has benefited greatly. Researchers can now use tissue samples—from either living birds or museum specimens—to determine the DNA composition of segments of selected genes. The chemical sequences of these samples are then compared to obtain objective information on the degree to which they differ. This becomes an additional characteristic, and a very important one, to weigh up alongside traditional characteristics in considering where species boundaries lie. The work has tended to establish ever finer differences: there is now a trend for more and more species and subspecies of birds to be recognised.

Biologists and rangers who studied brown kiwi in the wild at Ōkārito from the 1950s thought these birds were somewhat different from other South Island brown kiwi.

Recently, DNA studies confirmed this. In 2003 a paper in the international journal *Conservation Genetics* recommended that the North Island, South Island and Ōkārito populations of the brown kiwi should each be regarded as separate species. This is not surprising: since kiwi are flightless their ability to move around the country and intermingle is limited. And given their very long evolutionary history isolated in New Zealand, it is no surprise that DNA studies of brown kiwi have shown up significant geographic variations.

∽

Unfortunately, the authors of the paper did not stop at their excellent recommendation that the Ōkārito kiwi be recognised as a distinct species. They went on to coin a name for it, stating that "a new species, *A. rowii*, should be erected", rowi being a Māori name sometimes used for the Ōkārito birds. The authors may have thought this was all that was needed to describe a new species, or they may have been merely suggesting the sort of name that could be used. Whatever the case, they provided a name but did not meet other requirements of the International Code of Zoological Nomenclature.

The Swedish botanist Carl Linnaeus developed the system of naming organisms used today. Each species has a two-part Latinised name, such as *Homo sapiens* or *Tyrannosaurus rex*, rendered in italics to set it apart from ordinary text. The first part, always with an initial capital letter, is the name of the genus, a parallel to the surname in families because it may be shared by several entities that belong to it. The

second part is the "specific" name which, in tandem with the generic name, makes a combination that uniquely names the species of animal.

Our current system of animal names is decreed to have begun with the tenth edition of Linnaeus's book *Systema Naturae*, published in Sweden in 1758. Over the centuries, as might have been expected, naming has become horrendously complicated. Many of the species we recognise today have been unwittingly named numerous times before. In September 1895, at a meeting in Leiden in the Netherlands, an International Commission on Zoological Nomenclature was formed to regulate animal names. The commission deals just with names, not with the working out of species and other taxonomic units. Its aim is to maximise stability and universality of animal names, except where taxonomic judgement runs counter. There is no reliance on case law; instead rules are applied directly, and exceptions require an individual ruling from the commission. The rules of nomenclature—for example, that the oldest validly published name of a species has priority over later names—are set out in a code to which zoologists throughout the world are expected to adhere. The names of plants and micro-organisms are governed by parallel codes.

The code has many requirements. For instance, if a new animal is being named a single preserved specimen must be designated so it can "carry" the new name and be a point of reference in any future disputes or uncertainty. This is called the holotype. It is recommended that these and other kinds of "type specimens" be lodged in publicly owned museums, where they can be consulted on request and treated as the

property of science internationally. These specimens, of which there are millions around the world, are among the most important held by natural history museums.

The 2003 kiwi article neither nominated a type specimen, nor stated an explicit intention to name a new species. This made the new name *Apteryx rowii* a *nomen nudum*, or "naked name", invalid for taxonomic purposes. The name was also badly formed. In Latinised specific names the *–ii* ending is used to honour a male person: "rowii" suggests the animal is named after a Mr Row or Rowe. When using a Māori name of an animal as a specific name, it is a "noun in apposition". Hence the correct form for a bird called the rowi is simply "rowi".

The invalid name *Apteryx rowii* was repeated in an article in the *New Zealand Listener* in July 2003 and began to appear on internet pages. There was a prospect of it becoming widely used. At the time, a committee of the Ornithological Society of New Zealand had begun a ten-year project to prepare a new checklist of New Zealand birds. Several members of the committee studied the issue and we agreed to publish, as quickly as possible, a valid description of the new kiwi with a properly formed name. We got this out in December 2003 and, happily, the correct name *Apteryx rowi* has been followed by everyone since.

In the formal description of the Ōkārito kiwi, we had to designate type specimens. The problem was that no museums had any specimens of the bird, apart from a pre-1945 headless specimen at Canterbury Museum. It seemed that in recent times all bodies of kiwi that died accidentally at Ōkārito had been either sent for post-mortem examination

by vets, after which the bodies had been destroyed, or given to local Māori groups so the feathers could be used for making cloaks.

Some inferior, damaged, partial specimens were hurriedly rustled up: they could be used as secondary "paratypes" in the species description. And then luckily, at the crucial time, one intact kiwi did become available—Jammit. She was mounted by a taxidermist for Canterbury Museum.

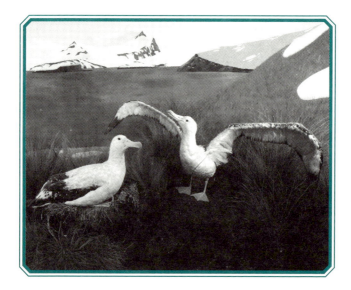

Leo Cappel's albatross diorama

On the natural history floor of the Auckland War Memorial Museum stands a magnificent diorama of a pair of large albatrosses in courtship display at their nest on a subantarctic island south of New Zealand. To one side a skua, dwarfed by the albatrosses, has brought food to its chick. The diorama is technically complex and artistically superb. A large viewing window, 2.4 metres wide, hides the edges of an even larger dome about 4.5 metres in diameter, the concave interior of which forms the back of the diorama. The birds occupy the foreground; a scenic landscape is painted on the inside surface of the dome.

Dioramas are a marriage of science and art: scientific accuracy in the composition of the scene and choice of elements is married to artistry in the background painting and the pose and set-up of the stuffed animals and the elements of their habitat. In any diorama, the tie-in between the background dome and the foreground is critical. In the albatross diorama, this junction is masked by the careful placement of tussock grasses, and the pretence that the land slopes away from the viewer towards the sea. The net effect

is a perfect illusion of a natural scene with broad and distant horizons. The glass is angled to minimise reflections.

When the diorama was built, the albatrosses were considered to be wandering albatrosses. Recently, this "species" has been broken up into several species and subspecies that breed on different islands. We don't know which islands the diorama birds came from, but they are probably what we now call Antipodean albatrosses, *Diomedea antipodensis*, which breed on the Antipodes Islands, Campbell Island and Auckland Islands.

Wandering albatrosses and their near relatives are the so-called "great albatrosses"—the world's largest seabirds. Their wingspan, at 3.5 metres, is the greatest of any bird's. These albatrosses range widely in the southern oceans, breeding at various islands. They have difficulty taking off from land, so they nest near a rise where winds will help them fly.

Antipodean albatrosses can live for as long as fifty years. To attract and retain a mate, they perform complex ritualised courtship displays, accompanied by beak-rattling and vocalisations that climax in a piercing scream. Having found a mate they stay with them for life. A single egg is laid in summer. Both sexes take turns incubating it for what is the longest incubation period of any bird—often more than eighty days. The parents brood and feed the nestling and it fledges the following summer. This is such a long breeding cycle that the parents breed only every second year.

Southern skua, *Catharacta antarctica*, are related to gulls and breed on subantarctic islands. While breeding they mainly eat eggs and chicks robbed from other birds' nests, and smaller seabirds that they catch and kill.

Auckland Museum's albatross diorama was built in 1970, but its birds go back to the 1930s. Up until 1929 the museum occupied a building in Princes Street. Here most of the collection was on display and the galleries were cramped. When it moved to a spacious new building on a hill in Auckland Domain, the modern approach of showing just a choice selection of the collection could be followed: less clutter and more style. There was now an opportunity for an entire gallery devoted to ornithology, and a Hall of New Zealand Birds was developed on the natural history floor at the front of the building.

The initial fit-out was a bit thin and, in the years that followed, displays were gradually augmented and improved. In 1933 a free-standing glass case was installed in the centre of the hall for a new exhibit featuring a pair of albatrosses at their nest. The male albatross, with wings outstretched, had been obtained in November 1931 by the chief officer of a passenger ship, SS *Marama*, in the Tasman Sea. The *Marama* was a Union Steamship Company boat, built in 1907 at Greenock in Scotland. It had served as a hospital ship in the First World War and continued in maritime service until 1937. Probably the albatross was found on board dead or injured after striking the ship by accident: it is unlikely any sailors would have shot an albatross.

The female albatross had been found near Dargaville, north of Auckland, in June 1932. It had probably washed up, freshly dead, on a local beach. Both birds would have been mounted by Auckland Museum's taxidermist, Charles Dover. In his twenty-four years at the museum, Dover prepared hundreds of mounts and study-skins. He was also

a skilled model-maker; during the war he would produce models of tropical fruits for use in teaching survival skills to Royal New Zealand Air Force personnel before they were sent for service in remote Pacific islands. To the same end, the museum in 1943 produced an illustrated booklet, *Food is Where You Find It – A Guide to Emergency Foods of the Western Pacific*, for castaway airmen.

In 1960 the museum building was doubled in size by an extension. Galleries were reorganised and a new bird gallery planned at the south end of the natural history floor. In 1970 the albatrosses were recycled into the diorama to provide a focus at the entrance to this new bird hall. The plaster dome was designed, built and painted, and the diorama's contents assembled, by the museum's preparator, Leo Cappel. Preparators are museum staff who build models and displays. A Dutch immigrant who had joined the staff in 1964, Cappel was skilled in all forms of this work, from backdrop painting and model-making to taxidermy.

The albatross diorama was not the only one: there were twelve dioramas of various sizes in the new bird gallery. The largest, seen straight ahead on entering the gallery, showed forest birds on a dry kauri ridge on Little Barrier Island. To the left, past some foliage, visitors could see the Hen and Chickens Islands on the horizon. Cappel had developed new techniques for the preservation of leaves, and in 1973 would publish a popular book, *A Guide to Model Making and Taxidermy*.

Sir Arthur Galsworthy, British High Commissioner to New Zealand, presumably stood in front of the albatrosses when he opened the bird hall in April 1972. This highly

successful gallery lasted until 1996, when the area was assigned to back-of-house storage and workspaces. The albatross diorama was to be replaced by something new, but this never happened. Today it has fresh importance as the only large, dome-backed diorama to survive the modernisations of the 1990s. Its technical complexity and artistry were unmatched by any of the new simplified habitat reconstructions, and in 1999 the preparator of the day, David Weatherley, cleaned the albatrosses and remodelled the groundwork.

There is a world crisis in museum taxidermy and concerns it may be a dying art. Essentially it is a western tradition, with no great strength or history elsewhere, and opportunities for training new museum taxidermists have steadily declined. While countries outside the west are building big new museums with natural history displays, the standard of taxidermy is often frighteningly low. Meanwhile, many western museums have destroyed their historic dioramas in successive waves of modernisation.

The pendulum may be about to swing again: there are signs of a renewed interest in historic taxidermy. Leading the way has been the American Museum of Natural History in New York, with a multi-million-dollar restoration of its magnificent diorama halls, where large stunning displays depict habitats around the world. If you cannot make it to New York just at the moment, next time you are in Auckland Museum study the forty-year-old albatross diorama. Have a look at some old friends you may have seen before. Admire the illusion of their cunningly contrived setting and wish them luck for the next forty years and beyond.

Auckland Museum. New Zealand

Auckland September 19 1877.

Dear Sir,

On the part of the Auckland Museum, I take the liberty of writing to you to ascertain whether it would not be possible to open an exchange of specimens with the Museum under your charge. The Auckland Museum has lately been thoroughly re-organised, and I hope in a short time to have

Answd. 24 Nov. 1877 — E/J/85

Willie Cheeseman's reef heron

In 1946 in a gallery at Auckland Museum, Lady Freyberg, wife of the governor general, unveiled a delightful plaque—bronze with inlaid paua shell—designed by an Auckland sculptor, Richard Oliver Gross. She named the gallery the Cheeseman Hall.

Thomas Cheeseman is something of a hero for Auckland Museum's natural history curators. He served as the museum's sole curator for forty-nine years, from his appointment as a young man in 1874 to his death in 1923. He alone was responsible for all collections at the museum until he gained an assistant, Louis Griffin, in 1908. While a strong advocate of the museum's work and a top biologist, he was by all accounts a quiet achiever and a gentleman.

Cheeseman effectively founded Auckland Museum as a professional institution, developing it from a small-town amateur affair to a fully fledged Edwardian museum suited to a small but growing colonial city. In 1867, Frederick Hutton, the museum's honorary curator, had contacted Julius von Haast at Canterbury Museum concerning a possible exchange of specimens. "The Museum here," he wrote, "is

such a wretchedly poor one that it will be impossible for me to send you anything at all equal to the value of your Moa bones for some time to come." Cheeseman changed all that.

He was primarily a botanist. There was no university in New Zealand when he was young so he taught himself: his *Manual of the New Zealand Flora*, first published in 1906, was one of his greatest botanical accomplishments. He also seemed to handle non-botanical curatorial requirements with ease, presiding over the development of diverse natural history collections and the museum's early acquisitions in what are today world-class collections of Māori and Pacific ethnology.

Under Cheeseman's guidance the bird and mammal collections grew steadily; today many specimens still bear his accurate handwritten labels. He started a numbered register of land vertebrates, which listed for each specimen the registration number, species, date received, place of origin and donor. This "blue book" remains the starting point for the documentation of most of the museum's early specimens. For some entries the date column is simply annotated "In Mus. 1874", hinting that record-keeping was poor before Cheeseman came on the scene.

He was an energetic correspondent, writing regularly overseas and within New Zealand to arrange large exchanges of specimens which would rapidly develop the museum's collections. New Zealand birds were a popular currency in international exchanges, and Cheeseman needed to acquire surplus specimens. At times he was able to purchase prepared bird skins from collectors or dealers such as W. Hawkins and Sigvard Dannefaerd, who both collected in the Chatham

Islands, and William Smyth, a commercial taxidermist in Caversham, Dunedin, but this option was expensive and thus severely limited by the museum's perennially straitened circumstances. Up to 1908, a common refrain in the *Annual Report* was that the museum could not afford to employ a taxidermist.

With necessity the mother of invention, Cheeseman enlisted his own family in a solution to the taxidermy problem. His younger brother William Joseph, a building contractor, was handy with a gun and seems to have had an interest in and aptitude for shooting birds. Over several decades he shot hundreds, with a peak around 1880 when he was in his twenties, and passed them to his brother for the museum.

But how could the birds be processed into stable skins? The Cheeseman men had three sisters, Emma, Ellen and Clara. The family was well off and the sisters were free to fill their days with pursuits such as embroidery, sketching and painting. Emma, the eldest sister, either volunteered or was persuaded to take up taxidermy, which she mastered well, producing tidy study-skins with the legs neatly crossed and the heads of the longest-billed birds turned to one side. To a leg of each bird Thomas Cheeseman tied a label in his neat copperplate writing. Where Willie was the collector, the label was annotated "W.J.C.". On the backs of many labels, someone else, perhaps Emma herself, wrote "E.C." in pencil, presumably to note the birds she had prepared.

Interested in Cheeseman's large international exchanges, I studied the correspondence he carried out with Enrico Giglioli, director of the natural history museum in Florence, Italy. There are fifty-two known letters from at least sixty-three that the men exchanged between 1877 and 1904. These delightfully written letters give a detailed account of the exchanges and the attendant issues and concerns. In time, despite the slow postal service, high cost of freight, need for agents, pillage en route, and delays caused by port strikes and unscheduled transhipment, much was achieved. More than six hundred Italian and foreign birds and other land vertebrates were sent to Auckland, while one hundred and fifty New Zealand birds and numerous Māori and Pacific ethnographic items were sent to Florence. There were also exchanges of pressed plants, insects, and academic periodicals—the bulletin of the Italian Entomological Society was exchanged for *Transactions and Proceedings of the New Zealand Institute*.

Giglioli had been born in London to an English mother and an Italian father in political exile. After his school years in England, which explain the perfect English of his letters, he had returned to Italy to attend university. He had then signed up as assistant naturalist on a round-the-world voyage of an Italian warship, the *Magenta*. At Hong Kong in 1867 the chief naturalist, Professor Filippo de Filippi, died of cholera, and Giglioli, aged twenty-two, had to take charge of the scientific team.

The *Magenta* voyage has a link to New Zealand, for south of Pitcairn Island the team collected a new species of seabird, which Giglioli and another ornithologist, Tommaso

Salvadori, described and named in 1869 *Pterodroma magentae*, the Magenta petrel, in honour of the ship. Today it is also known as the Chatham Island taiko. One of the world's rarest birds, it breeds in the forested south-west part of Chatham Island, some 850 kilometres east of mainland New Zealand. The taiko once bred in vast numbers but exploitation by Moriori, the indigenous people of the Chathams group, and by introduced predatory mammals reduced numbers so greatly it was thought to have become extinct. It was rediscovered in 1978 by a determined naturalist, David Crockett, who spent many years searching for it. Photographs and measurements of the bird established that it and the Magenta petrel were the same species.

After his voyage on the *Magenta*, Giglioli obtained employment in Florence, including the directorship of the natural history museum, which he held until his death in 1909. In their nearly three decades of correspondence, he and Cheeseman never met and never proceeded beyond "My Dear Sir" and "Dear Colleague". However, a few glimmers of their personal lives crept in. Delays in replying often elicited concerned enquiries as to health. Cheeseman had on one occasion been ill, which for a time had "laid me on one side altogether". Another time severe illness had afflicted Giglioli's wife, who "is now, thank God, well again". Cheeseman was also late in writing because of his marriage to Rose Keesing in November 1889 and his expedition soon afterwards to the northern Three Kings Islands, on which his wife accompanied him.

In the land vertebrates storeroom in Auckland Museum I viewed the hundreds of surviving animals from the Florence

exchanges; many still had original labels in Giglioli's hand. In 2007 I spent three days at the museum in Florence to see the New Zealand birds Giglioli had received in exchange. To reach Museo Zoologico e di Storia Naturale, usually known as La Specola, from my modest hotel near the railway station, I had the pleasure each day of walking across town and over the Ponte Vecchio. La Specola first opened to the public in 1775 and I was expecting a building with a grand facade. On my first day, I walked up and down a section of the narrow street several times before I studied the street numbers and realised I had been passing the small museum entrance.

I was helped by several of the staff. First, I needed a short lesson in Italian vocabulary to understand the field names in the computer catalogue. From the computer I could scan the records of New Zealand birds and find those from the Auckland exchange that I wished to see. I sat in a workroom next to the office where Giglioli once worked. A French door was open to a small balcony—thick with leafy vines—that looked out on the enclosed museum garden.

The bird specimens were brought to me in batches from storage. I particularly wanted to see any rare species, and I also wondered if there were any Cheeseman family birds. There were several: I saw at once that Willie's shooting and Emma's stuffing had helped fuel the Florence exchanges. I particularly remember a nice study-skin of a reef heron, one of New Zealand's native water-birds. Cheeseman's writing on the original label showed it had been collected in Auckland's Orakei Basin on March 4, 1879. The letters "W.J.C." told me who the collector had been and the preparator was signified by "E.C." on the reverse.

It was good to see proof that the New Zealand birds had made the journey across the globe. The earliest ones had gone from Auckland by sailing ship, probably the barque *Alastor*. They had then survived the turmoil of one hundred and twenty years of Italian history, during which time fascists came to power and were driven from power and a monarchy gave way to a republic. In August 1944, while the birds sat in the museum's ornithological collection, New Zealand Army units had entered a liberated Florence during the Italian campaign.

On the final afternoon I saw the special galleries for which the museum is famous. They contain innumerable eighteenth-century wax models of human anatomy prepared for medical teaching. The detail and accuracy of these virtual dissections was staggering. After an hour of peering closely at every inch of the human body from inside and out, I needed fresh air. I retreated to the Boboli Gardens next to the museum for some final views of Florence and the rolling Tuscan hillsides, and contemplated the extraordinary and enduring legacy of Thomas Cheeseman.

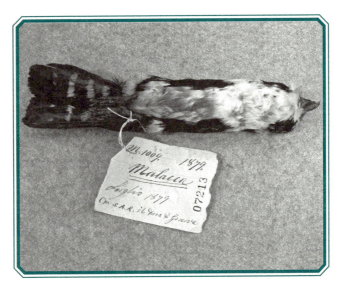

The Duke of Genoa's black-thighed falconet

Among the thousands of study-skins of birds arranged on trays in the cupboards of the land vertebrates storeroom at Auckland Museum there are many foreign birds. Most of these birds, which are exotically shaped and coloured in comparison to the local species, are from exchanges carried out in the late 1800s; the original labels, tied with fine string to the birds' legs, are annotated in the loveliest of handwritings.

It was many years before I began to understand the wealth of history bound up with these old skins. Seven birds are annotated as coming from Malacca in the Malay Peninsula. All have the same simple paper labels, which have been cut from lined sheets. In 2001 I asked an Italian intern at the museum to translate the expression "Da S.A.R. il Duca di Genova" that appeared at the bottom of each label. Of course, it means "From H.R.H. the Duke of Genoa". I began a correspondence with Carlo Violani at the University of Pavia; Violani had published papers on Italian historical bird collections and was able to give me information on these and other specimens.

Although the birds were from Malacca, it turned out that the skins had been purchased in Singapore in July 1879 by members of an expedition to the Far East on the Italian corvette *Vettor Pisani*. The two-year expedition was led by Prince Tommaso of Savoy, the second Duke of Genoa and nephew of the king of Italy.

Back in Italy, the birds that had been gathered were studied by Tommaso Salvadori, an Italian count, and Enrico Giglioli, the director of the natural history museum in Florence. Together they published an account of them in 1888. When the birds had been studied, some became "duplicates" available for exchange, and Giglioli included these seven in a consignment sent that year to Thomas Cheeseman, curator of Auckland Museum.

One of the Duke of Genoa's bird skins is a black-thighed falconet, *Microhierax fringillarius*. This bird is about the size of a house sparrow, and at a passing glance you could mistake the skin for that of an inoffensive songbird. However, closer inspection shows it is a miniature bird of prey, with the same fearsome hooked beak and talons of its larger relatives. There are several species of falconets and all of them live in, or at the edges of, the forests and woodlands of tropical Asia, where they hunt mostly large insects in the tops of trees and nest in tree holes.

Another Italian explorer-naturalist of the 1870s was Odoardo Beccari. He and a compatriate were the first Europeans to explore the interior of western New Guinea, and Auckland Museum received two Beccari birds from this region, again via Enrico Giglioli. The specimens went first to Museo Civico di Storia Naturale in Genoa, a museum that

had been founded in 1867 by Marquis Giacomo Doria, a naturalist. Here they were studied by Salvadori for his three-volume monograph on the ornithology of New Guinea and the Moluccas. From there the two birds went by exchange to Giglioli in Florence, and from him to Auckland. One is a rufous-bellied kookaburra, the other a colourful ground-dwelling forest bird called a red-bellied pitta. Both were collected in 1875.

Like Thomas Cheeseman at Auckland Museum, Odoardo Beccari was principally a botanist, and during explorations in Sumatra in 1878 he discovered the plant for which he is most famous—the titan arum. This rare plant has the largest unbranched flower-cluster in the world: it can stand over three metres tall. Because of its fetid smell, the titan arum is also called the corpse plant. Cheeseman and Beccari met the following year when Beccari visited Auckland. Cheeseman later sent Beccari seeds of New Zealand's nikau palm but the seeds could not be made to germinate in Italy.

In 1879 Auckland Museum got more New Guinea birds, purchasing them from a thirty-nine-year-old Scotsman, Andrew Goldie. A naturalist, explorer and merchant, Goldie was based in New Guinea from 1876 until his death in 1891. He owned Port Moresby's first general store and discovered gold near the settlement in 1878, engendering a small gold rush. Many of the birds that went to Auckland may have been collected by his assistant Carl Hunstein, an albino German, who was later drowned by a tsunami while collecting on the west coast of the New Guinea island of New Britain in 1888.

Another Scotsman, Henry Forbes, in 1885 published *A Naturalist's Wanderings in the Eastern Archipelago*, a detailed and gripping account of his travels in the Dutch East Indies, now Indonesia. For part of his intrepid journeying Forbes was accompanied by his new wife Anna, who would publish her own account in 1887 under the title *Insulinde: Experiences of a Naturalist's Wife in the Eastern Archipelago*.

Henry Forbes complained of the hostility and "absurd and petty jealousy" of the Dutch Resident at Amboina, J.G.F. Riedel, who obstructed his travels to certain islands. There had long been ill will between the Dutch and the British over these "Spice Islands" and in addition Riedel was himself a bird collector: Auckland Museum has nine studyskins from the Celebes, today's Sulawesi, which he obtained in 1875. Forbes has a connection with New Zealand: he went on to become the director of Canterbury Museum from 1890 to 1893.

Some nineteenth-century bird collectors were wealthy industrialists. One such was Henry Seebohm, a Sheffield steel magnate, who built a private collection of 20,000 birds between about 1870 and 1895. Seebohm travelled widely to pursue his interest in ornithology: his published books included two on birds of Siberia and one on birds of Japan. Through the Auckland Museum's exchanges with Florence, one of Seebohm's birds found its way to New Zealand—a crow collected in Siberia in May 1877, probably near an encampment where Seebohm and his expedition waited for ice to break up at the confluence of the Yenesei and Kuriaka Rivers.

Another specimen that came via the Florence exchanges was a black kite, a bird of prey that had been collected in 1867 at Amoy (now Xiamen) in China by Robert Swinhoe, British Consul in the city. Swinhoe, a passionate and energetic naturalist, explored large tracts of coastal China, made a couple of inland journeys, and served in several places as diplomat or interpreter, all the while collecting information for accounts, which he later published, of the bird life. While visiting Shanghai in 1873 he was stricken with paralysis in his legs. He struggled on, carried about in wheelbarrows or sedan chairs, but his health deteriorated further and he returned to London. He remained paralysed and died at the age of forty-one.

Thomas Cheeseman also arranged major exchanges of birds with the Smithsonian Institution in Washington, D.C. between 1886 and 1892. The hundreds of bird skins the Auckland Museum received are notable for the fullness of their labelling compared with the scant information on the labels of many New Zealand birds collected in the same period. Most of the Smithsonian birds were gathered in the wild west during exploration by the federal government, often carried out by army personnel at frontier outposts. Many of the pre-printed labels carry the names of lengthy expeditions such as "U.S. Northern Boundary Survey 1874" and "Explorations and Surveys West of the 100th Meridian". Collecting birds in the pristine wilderness was often an antidote to loneliness and boredom.

Among the Smithsonian collectors represented at Auckland are several well-known ornithologists of the day. Robert Ridgway was the first full-time curator of birds at the Smithsonian. Charles Bendire joined the United States Army at the age of eighteen, fought in the American Civil War, and in 1890 was promoted "for gallant service in action against Indians at Canyon Creek, Montana, in 1877". He spent around twenty years in the western territories collecting birds and their eggs. Some of his study-skins at Auckland Museum came from military outposts such as Fort Custer and Fort Klamath. He once climbed twelve metres up a tree to collect a hawk egg, and carried it safely in his mouth when he had to descend hurriedly to escape a band of Apaches.

Elliott Coues was a surgeon in the United States Army and a founding member of the American Ornithologists' Union who pioneered the use of the subspecies concept for regional populations of birds, each distinguished by three-part names. Henry Henshaw collected more than 13,000 bird specimens in North America. Coues and Henshaw are reported to have once raced each other, and found each could prepare a sparrow study-skin in under two minutes. This would have been quite a feat: the fastest skinning that I have seen was by a museum preparator in Australia, who worked fast and furious to produce a magpie skin in under thirty minutes.

Another Smithsonian collector, Edward Nelson, is said to have alleviated the climatic hardships he endured during trips in western Alaska by paying Eskimo women to sleep in his wet clothes so the garments would be dry by morning.

There were also great dangers. Robert Shufeldt, an American scholar who published an article in 1918 on the osteology, or bone structure, of New Zealand's alpine parrot the kea, drowned in the Ohio River near his home. In the Dakotas in 1864, Sergeant John Feilner galloped ahead of his column in his eagerness to collect birds; while dismounted at a stream he was surprised by Sioux warriors and killed. Bird skins from both men are in Auckland Museum.

The most famous collector of the Smithsonian birds sent to Auckland was Theodore Roosevelt, whose name inspired the teddy bear. In his younger days the future president was a keen hunter and shooter who built up a collection of study-skins of local birds. Later in life he became a pioneering conservationist. As governor of New York he closed down hat factories that used bird feathers. During his presidential term from 1901 to 1909 he achieved more for wildlife protection than any previous president, creating numerous national parks and reserves. He gave his bird collection to the Smithsonian, and nine duplicate specimens came to Auckland Museum as exchanges.

Old specimens in natural history museums, provided they have been carefully documented and faithfully numbered and labelled, tell many such stories—not just of bygone days and remote and exotic places, but of the passion of the collectors and the troubles they endured to bring or send the specimens home. Today, museums get fewer of their birds from intrepid expeditions. Many specimens are salvaged

from accidental bird deaths. Members of the public play a critical role by offering museums dead birds they find crashed into windows, lying on the roadside, or washed up on beaches. Bird curators often keep in touch with field officers, post-graduate biology students, bird-rescue volunteers, and other people who show an understanding of the value of museum collections and take great trouble to collect and label any dead birds they find during their work. For every new specimen received, we record the collector's name: even seemingly ordinary specimens may be of great interest to future generations because of the identity of their collectors.

In the early 1970s Auckland Museum received three wading birds from the Delaware Museum of Natural History. When you look at these birds they seem very drab and pedestrian—until you discover they were collected in the 1950s by John Eleuthère du Pont, a member of the American industrial family. Du Pont, an ornithologist whose interests included South Pacific birds, founded the museum in 1957 and directed it for several years. He described a new subspecies of parrot-finch from Western Samoa, and in 1976 published a guide to South Pacific birds, beautifully illustrated by George Sandström.

Du Pont was also a stamp collector and apparently paid nearly a million dollars in 1980 for the unique 1856 British Guiana one cent black-on-magenta, perhaps the world's most famous postage stamp. In his private life he displayed increasingly bizarre behaviour. A major supporter of wrestling, with dreams of personal glory, on January 26, 1996 he shot and killed David Schultz, the 1984 Olympic

wrestling champion who lived on his estate in Philadelphia. Convicted of third-degree murder, du Pont died in prison in 2010.

A long-remembered ovenbird nest

One day I received a telephone enquiry about a bird's nest that had been in a family's possession for many years after a forebear collected it in South America. It was said to have been later presented to Auckland Museum. After the telephone call I was pleased to find the nest listed in the catalogue system and the object itself in the storeroom. The nest was accompanied by a section of the branch on which it had been built; there was also a stuffed ovenbird perched on the nest and another on the branch.

The elderly caller made an appointment to view the nest. When I took him into the storeroom and opened a cupboard to reveal it, he burst into tears. The sight evoked old memories: he had known the nest during his childhood some seventy years before.

Ovenbirds get their name because some species build large enclosed nests out of mud and the finished result looks like a clay oven. The thick-walled nest is reinforced with straw, hair and other fibres, and the eggs are laid deep inside on a bed of soft dried grass. The museum nest, and the two birds mounted with it, were of the species red ovenbird or

rufous hornero—*Furnarius rufus*—a brown thrush-sized bird that is the national bird of Argentina. Red ovenbirds live in fairly open areas, often close to human habitation, and place their nests in conspicuous positions, such as on bare forked branches or the tops of posts.

In any sizable city it is never long before somebody with a historical, cultural or scientific question thinks to ring the museum, or visit it in hope of seeing an expert in person. Queries about animals flow in from all quarters, from academics and tertiary students, school pupils, people with a burning interest in nature, and specialists in the commercial sector, from book publishers in Australia to documentary researchers in Britain. I once received a telephone call from a family in Ohio whose daughter was doing a school project on New Zealand birds.

The enquiries vary greatly. In my department, we receive questions about birds and their life history, about the museum's birds on display or in storage, and about ornithology and ornithological organisations. One day someone rang me urgently from Wellington to ask if kiwi mate for life; he was a speechwriter for a company boss who was delivering a speech in eight minutes' time. I was able to tell him it seems they probably do. A city council arborist asked about the breeding season of herons in order to schedule the felling of tall trees at a safe time, and people cutting suburban hedges ring with the same issue with regard to the nesting of small garden birds.

One caller had seen fast-moving flies in the plumage of his pet parrot, and I was able to tell him about louse, or hippoboscid, flies. These quite large flat parasitic insects are

sometimes seen when you handle wild birds, and the speed of their movements is amazing. I thought I was seeing things the first time a hippoboscid landed on my hand and then returned in a flash to conceal itself in the plumage of the bird I was holding for banding.

Most curators are highly accessible and may in effect be on standby all day to deal with public enquiries. When I started at Auckland Museum in 1982 there was an archaic but delightfully simple paging system. The offices in the administrative section of the museum looked out across a large internal courtyard to a high blank wall, which was the back of the public galleries. High on the wall was a large flat circular light that flashed a short morse code repeatedly in dull crimson when activated by the receptionist. (My own call-sign was short–long–short–short–short.) If you were away from your telephone, you looked periodically through any convenient window to see if the light was flashing. In some corridors there was also a warning sound to indicate that paging was in progress. Today there are many more landlines in the building, not to mention mobile phones.

Perhaps the most common question I receive is along the lines of "What bird have I just seen (or heard)?" This is often easily sorted from the person's description of the bird's size, shape and colour. Bird calls are much less easily resolved from phone descriptions—even when the enquirer, in desperation, says such inventive things as that the sound reminds him or her of a phrase in the third movement of

the Bruch violin concerto. Callers have sometimes played me barely audible recordings of a mystery songster, or taken a cordless telephone into the garden to be closer to a bird calling in the background.

Over the decades many enquiries have concerned welcome swallows (*Hirundo neoxena*), spur-winged plovers (*Vanellus miles*) and spotted doves (*Streptopelia chinensis*). The swallow and plover arrived of their own accord from Australia and in the last fifty years have spread throughout New Zealand. The enquiries have come from people who, for the first time, have seen these birds closely, found them breeding, or heard them calling. The welcome swallow, which flits about at great speed with its pointed wings and deeply forked tail, is easily identified by most people, but less so the first sight of its mud nest plastered to the side of a garage or shed. When these birds first arrived they tended to nest in the most inaccessible places—under tall bridges, for example—but as their numbers built up they were forced to nest closer to human habitation. They are now one of the commonest small birds in the country.

Spur-winged plovers arrived in the 1930s and began breeding in the far south of the South Island. They gradually spread, and were first seen breeding in the south of the North Island in the early 1970s. My early years at Auckland Museum coincided with the proliferation of these birds in the Auckland region. Large plovers, they have a brown back, white underparts and a black and white head. The adults have a big spur at the bend on the leading edge of their folded wing (actually the "wrist"). They also sport a fleshy yellow facial patch with pendulous wattles; this leads to

their alternative name the masked lapwing, because they look like a dandy at a masked ball. Spur-winged plovers fly slowly but with urgent, clipped wing-beats. With their loud penetrating call, which has been called a staccato rattle, and their fondness for paddocks and grassy fields, they soon attract attention.

The spotted dove is an escaped cage-bird of south-east Asian origin that has been breeding in low numbers around Auckland since the 1920s. Recently, for unknown reasons, it has become much more common, and more likely to be noticed by residents in the greater Auckland area. Spotted doves are smaller than city pigeons, and predominantly brown with grey and pinkish tones. Adults have a black band finely spotted with white on the back of the neck. They have a distinctive and often persistent cooing call.

In summer, when the tall New Zealand flax is in flower, common starlings that feed on the nectar often get orange-red pollen smeared on their foreheads. This is usually the explanation when people ring with questions about birds with orange heads. At one time it was popular to build wooden nest-boxes for the garden and people often asked what diameter the entrance hole should be to admit common starlings but exclude common mynas. (The answer is not more than forty-five millimetres.)

Another common enquiry is about mystery bones discovered at a beach, on a farm, under a house, or in a cave, swamp or sand dune. Usually the bones need to be brought to the museum for direct examination, and we compare them with reference specimens in the collection. Increasingly, however, an emailed digital photograph will

do the job, or at least narrow down the possibilities. With large bones there is always the chance they may be of moa, New Zealand's extinct wingless birds. Occasionally they are. Other bones brought in and added to our collection have belonged to similarly extinct birds such as the North Island adzebill, the North Island goose and the New Zealand coot.

In even rarer instances, an enquirer will bring in human bones eroded out of prehistoric Māori burial sites. Most often, though, a mysterious bone is from a domestic animal such as a sheep or cow; we have an articulated cow skeleton in the land vertebrates storeroom, useful for pointing out which bone has been found.

I always thank people for bringing in bones, whatever they turn out to be, because it is important to check them. Once I drove forty kilometres to a harbour headland to find that bones a farmer had uncovered in a pit were horse bones. Similarly, "dinosaur" bones in a south Auckland garden proved to be whale bones.

Another regular enquiry is about bird bands. Each metal band, or ring, a biologist places on the leg of a bird has a unique number that identifies the bird individually. The New Zealand National Banding Scheme for wild birds is run by the Department of Conservation, but used to be run by the museum in Wellington. Older bands say "SEND DOMINION MUSEUM NEW ZEALAND" or a variation of this, and other bands may have "NATIONAL MUSEUM" in the inscription. Dominion Museum became the National Museum of New Zealand, and then the Museum of New Zealand Te Papa Tongarewa, often contracted to "Te Papa". It is surprising how many senders wrongly add Auckland to

the address on the bird band, and how many postal workers think the national museum is in Auckland. The result is a constant trickle of bands, or reports of bands, which we redirect to the banding office in Wellington.

Other jurisdictions have also had trouble with inscriptions on bird bands. In the United States, bands at one time read "WASHINGTON BIOLOGICAL SURVEY", abbreviated on smaller bands to "WASH. BIOL. SURV." There is an apocryphal tale about an Arkansas farmer who wrote in to complain that, after he shot a banded crow, his wife followed the cooking instructions helpfully provided on the bird's leg but the bird tasted horrible.

Recovering and reporting bands from dead birds provides data vital to establishing movements and minimum ages of individual birds. In 1997 a common tern, *Sterna hirundo*, that had been banded in Finland was caught (and released again) on the Victorian coast of Australia after a journey, probably via South Africa, of over 26,000 kilometres, the longest documented journey of any bird. In New Zealand, the centralised national banding scheme began in 1950 and the millionth bird was banded in 1987. There have been over 400,000 recaptures or recoveries of banded birds, including a gannet, *Morus serrator*, that had travelled over 5,000 kilometres from Cape Kidnappers in the North Island to Western Australia, and a house sparrow, *Passer domesticus*, that had moved over 300 kilometres from Upper Hutt, north of Wellington, to Reparoa, midway between Taupo and Rotorua. A royal albatross nicknamed Grandma bred regularly at Taiaroa Head near Dunedin and the banding of this bird from 1937 established that it lived over sixty years.

The banding office replies to every sender of a band, telling them where, when and at what age the bird was banded, and what the discovery shows. Unfortunately, many senders do not think to open and flatten the band—which is not easy to do anyway with the larger stainless steel bands— and instead post it in its circular state. I have received a few empty envelopes where the curled band has burst out during transit and been lost, along with its number. It is always advisable to note the band's number in the accompanying letter. In most cases it is in fact enough just to report the number and keep the band.

∽

Some enquiries we receive are trivial. People in a pub may be trying to settle an argument about the size of an animal. Others may want help to solve a crossword puzzle clue. Some callers seem unable to end their conversations. They move on beyond the original issue to other birds they have seen in their gardens, and perhaps, if you are not careful, to all the interesting birds they have ever seen on holidays at home and abroad.

Not everyone accepts a curator's advice. A man brought in what he believed was a fossilised bird's head. When I told him that in my opinion it was just a rock—although unquestionably a very interesting rock—he went into denial. "But look, you can see the eyes," he insisted.

Then there are the eccentrics. A woman rang to say that she had worked out why the Mayan temples were built, and did I know that catastrophic tragedies recur every 7,000

years? Once I received a letter that comprised a photocopy of a foreign postage stamp depicting a lizard. On the rest of the page, presumably for my personal benefit and future reference, were written out in capital letters various facts about the country and the lizard. But the strangest thing was that several places on both the letter and the envelope were rubber-stamped "CHECKED" and this notation was countersigned for added validity.

One time when both marine curators were absent, the receptionist, as a last resort, put a call through to me from an elderly woman in a grumpy mood. She wanted to know the name of big jellyfishes that had been washing up in large numbers on the beaches of Auckland's eastern suburbs. I am hard-pressed trying to maintain a general knowledge of birds, reptiles (including dinosaurs), amphibians and terrestrial mammals, and have to confess to an appalling ignorance of jellyfish. More than once I explained politely that it was not my field, and that she would have to ring again when one of the marine biologists had returned. Was I or was I not a natural history curator, she asked. Did I or did I not have a zoology degree? Then why could I not answer her simple question? It occurred to me suddenly that I did not have to listen to this any longer. Without another word, I hung up: the only time among thousands of enquiries that I have needed such a desperate remedy.

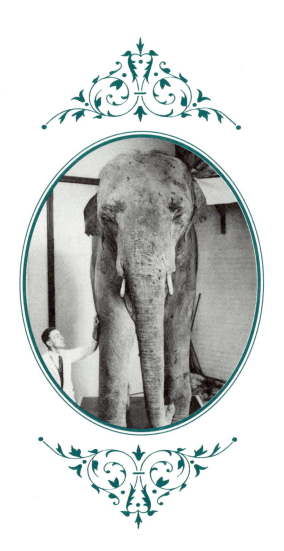

Rajah,
the elephant

In 1930 Auckland Zoo paid £125 to a zoo in Tasmania for a thirteen-year-old male Asiatic elephant. This species, *Elephas maximus*, and one or two species of African elephants are the largest living animals on land. As adults they are too big to suffer predation (except by armed humans) and may live for seventy years. Their most useful appendage is their trunk, a flexible muscular elongation of the nose and upper lip with the nostrils at the end. The trunk is strong enough to tear down a branch from a tree, yet terminates in a finger-like extension delicately dextrous enough to be able to pluck a blade of grass or pick up peanuts. The trunk is used to gather food and pass it to the mouth, to suck up water for drinking, as a means of breathing while swimming, and in social interactions such as caressing other members of the herd, restraining and guiding infants, and displaying aggression.

Rajah, who was supposed to be a companion for Auckland Zoo's other elephant, Jamuna, had probably been taken from the wild in Burma. From there he had gone to London to be exhibited with a group of elephants

at the 1924 British Empire Exhibition at Wembley. The following year he had been shipped to Beaumaris Zoo in Hobart, famous as the location where cine footage and photographs were taken of the last known living thylacine, the Tasmanian tiger.

In Auckland, Rajah proved bad-tempered and difficult to control. It was said that in Australia a sadistic visitor had traumatised him by placing a lighted cigarette in the tip of his trunk. This may have been the problem, or perhaps Rajah was just a troubled adolescent male reacting against change and dislocation. He spat at visitors and, unlike good-natured Jamuna, could not be trusted with giving rides to children. Finally his keeper could no longer handle him. There were few options, other than keeping him permanently chained. He was shot early on the morning of March 9, 1936 by a keeper with experience of big-game hunting.

The stuffing of mammals, birds and reptiles that died at the zoo was a convenient way of increasing Auckland Museum's collection, and so it was with Rajah. The museum staff included a skilful taxidermist, Charles Dover. Dover and his assistants spent seven months preparing the elephant as a mounted exhibit—no easy task given that Rajah was about three metres long, stood two and a half metres tall at the shoulders, and weighed nearly 4,000 kilograms. The fresh hide alone weighed about 500 kilograms; in parts it was five centimetres thick. This was one of the largest taxidermy jobs ever undertaken in New Zealand, ranking alongside the mounting of an Asiatic elephant that Andreas Reischek, an Austrian taxidermist, had carried out for Canterbury Museum around 1880.

On the day Rajah was shot, Dover and three zoo attendants spent all afternoon removing the hide after the body had been raised off the ground by block and tackle and a lifting jack. A makeshift screen hid this unpleasant scene from zoo visitors. That night the lions and tigers may have noticed a slightly unusual meat for dinner.

Rajah's skin and bones were taken across town to the museum. There visitors were able to view the work in progress, which created as much interest as the final display. Three weeks were spent on the hide, scraping and paring down the inside to remove fat and connective tissue. Meanwhile the bones, cleared of flesh, were placed on the museum roof to weather. Accurate measurements of these bones were crucial for fabricating the false body on to which Rajah's skin would be fixed. Some of the enormous bones are still in the museum's osteology collection. Big though the long leg bones are, their incomplete ends testify that Rajah was still growing.

Dover built a precisely measured framework of timber struts and iron rods, incorporating papier mâché casts of Rajah's skull and pelvis and wooden replicas of the ribs. The framework was finished with a layer of fine wire netting, covered with scrim and packed out in places with fine wood shavings. The outer layer was papier mâché, painted when dry so as to be waterproof. Finally, the elephant's wet skin was taken out of a tank of preservative and slid into place on the framework, which had been oiled to make the job easier. While the skin was still pliable the cut edges were sewn together, final adjustments were made, and the finished mount was left to dry.

∽

In October 1936 the reincarnated Rajah went on display in the Hall of General Natural History. The museum's annual report congratulated Mr Dover "on a fine piece of taxidermy" and the elephant settled down to his role as one of the museum's biggest single items and a notable attraction. When I first knew him, in the early 1980s, he held pride of place in the centre of the hall, surrounded by a strong wire-mesh barrier that was chest-high to a man but only knee-high to Rajah. He shared this distinguished spot with a giant Seychelles tortoise and a very large alligator. During this period the museum employed its first conservators, and one of their earliest projects was improving the condition of a seam at the back of one of Rajah's legs.

In the mid 1980s someone scaled the barrier and tore off part of Rajah's tail. The damage was quickly noticed and the attendants on every floor went into high alert, their walkie-talkies crackling with urgent messages. Two suspicious-looking characters—just the sort who looked like they might steal the tail from an elephant—were followed at a distance, but to no avail. The tail was never found.

By the late 1980s Rajah's condition was a little embarrassing. After fifty years on open display in bright light, he was dusty and faded. The seams on his legs and trunk were unsightly and, as well as the damage to his tail, there were tears and punctures in his skin. He was inspected twice—by the taxidermist from the National Museum of New Zealand and by a pair of preparators from the Museum of Victoria, Melbourne—to see if he could be restored.

Both inspections revealed serious defects. The metal in the supporting framework, especially the sheet metal in the ears, was rusting. Lubricating grease used during the original taxidermy was seeping to the skin surface and oxidising. Any remedial work would be cosmetic and temporary.

In the early 1990s the museum was set to embark on a much-needed upgrading of its permanent exhibitions. The gallery in which Rajah stood, one of the most outdated, was earmarked for closure to create temporary storage and working space. What to do with Rajah became an issue.

Near the end of 1992 Rajah was moved with difficulty down the stairs to the main foyer. There he was elevated more than two metres on a brightly painted pedestal. A colourful howdah, or riding carriage, was strapped to his back and into this was placed a magnificent stuffed peacock from the bird collection, and an open parasol. At the press of a button, a recording of elephant trumpeting reverberated around the foyer. A label gave the elephant's history. At the end was added: "Please help us decide on Rajah's future. What do you think should happen to him?" This led to a deluge of contributions, most of them impractical, nonsensical or obscene.

Managers explored various possibilities and in the end decided to store the elephant off site. In March 1994 Rajah left the museum where he had been exhibited for fifty-eight years. His departure was a public event. The night before, he was taken out through the front door to the steps of the museum. He did not quite fit through the door, but this was fixed by cutting off his legs and trunk with a chainsaw. The next morning a small crowd gathered to hear a speech from

the governor general, Dame Catherine Tizard. An Indian dance troupe circled Rajah, and mounted on a trailer, the scars on his reattached appendages hidden by bandages of gold cloth, the elephant set off down the hill to the farewell strains of "Haere Rā", sung by the museum's Māori cultural group.

About a year later, someone told me there was a large photo of Rajah in a magazine—he was depicted in the warehouse of a storage company—and his small immature tusks were missing. We had overlooked the intrinsic value of the ivory in Rajah's tusks. They were never recovered.

Things quietened down until January 1998, when one of the new museum managers rang me to say he had had a curious answerphone message from a storage company. They had a large item in their warehouse. It belonged to the museum and they wanted us to do something about it. Could he have heard right? "They said it's an elephant!" Rajah had come back to haunt us.

By now the museum had a preparator with experience restoring museum elephants in Britain, so it was possible to have Rajah's appearance improved and the elephant worked his way into planning for one of the new social history galleries, which had the theme of connections with childhood. He came back to the museum in June 1999, this time entering through a hole created by removing a large side window, so no more amputations were needed.

In ten weeks, David Weatherley, the preparator, cosmetically restored Rajah by remodelling his damaged ears and fashioning replicas to substitute for his missing tusks and tail. He strengthened his legs internally using

aluminium rods. He cleaned his skin, filled holes—especially the amputation scars and gaps along the stitching lines—and painted the outer surfaces an elephant grey. Rajah looked surprisingly good.

On New Year's Day 2000, just a few weeks after the restored elephant had been unveiled, ivory hunters—or just plain old vandals—broke off his right tusk. A stronger false tusk was installed. This was followed by minor vandalism to the tail. Today, cracks are evident in the cosmetic repairs of 1999 and more conservation work is needed, but I am glad Rajah is still on display. Regular beauty treatments may keep him going another seventy-five years. In Moscow and Beijing, crowds of the respectful and curious line up to see the precariously embalmed bodies of the revolutionaries, Comrade Lenin and Mao Zedong. Perhaps Rajah—the angry young elephant—can be Auckland's equivalent.

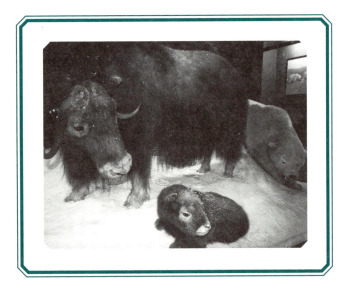

Mr Mackechnie's Arctic group

In the late nineteenth century Auckland's only zoo was the "gardens" of the Auckland Acclimatisation Society in the Domain, where the public could see a limited range of captive birds and mammals. Coloured books were too expensive for many households, so it fell to Auckland Museum and the city's public library to inspire citizens with a real taste of the wonders of the animal kingdom.

The museum evolved a grand plan to fill the centre of the main hall of its Princes Street building with groups of large mammals, which its annual report for 1899–1900 hoped "would enhance the appearance of the Museum, and add to its value as a means of recreation to the general public".

Edmund Augustus Mackechnie, a solicitor and local politician, had served on the museum's governing board and knew of this plan. When he died in 1901, Auckland Museum Library and Auckland Art Gallery were major beneficiaries in his will, but there was also a smaller bequest of £500 to Auckland Museum to procure groups of large stuffed mammals and the necessary showcases in which to display them.

The museum curator, Thomas Cheeseman, could now at last place orders with the prominent London taxidermy firm of Edward Gerrard & Sons, from whom Cheeseman expected "a higher class of taxidermy than we could hope for in the Colony". Gerrard & Sons began in 1850, flourished during the late Victorian and Edwardian heyday of taxidermy, and persisted until 1967. Its prices were lower than those of its more famous London competitor Rowland Ward and the work more variable in quality, although its best work was exemplary.

Gerrards produced an extraordinary range of products, from habitat groups for museums to trophy heads on shields, birds in glass cases, and a startling diversity of "animal furniture". Its mounted mammals were supplied to museums in Sydney, Melbourne and Perth, to the British Museum (Natural History), and to museums in Europe, North America and Africa.

The museum had a wish list of particular exotic mammals but this had to be tempered by availability. Gerrards proposed an "Arctic Group" comprising a polar bear (*Ursus maritimus*) and three musk oxen (*Ovibos moschatus*)—two adults and a calf. Cheeseman specified "plenty of action in the group, always provided that the attitudes, etc, are correct and characteristic, and true to nature". The final arrangement had the ever-hungry polar bear prowling at the edge of the oxen, showing an uncommon interest in the young musk ox.

Musk oxen roam the Arctic tundra, where they eat grasses, sedges and herbage. They live in groups of ten to twenty, and at times of danger bunch together, often in a

circle or semicircle with the calves inside. The largest males reach 400 kilograms. The coarse outer guard hairs shed rain and snow, and protect an inner coat of fine soft hair that keeps out the cold.

Polar bears, the largest of all living bears, are predators of musk oxen and other animals such as seals. Their front paws are large and oar-like to assist swimming. The soles of their feet are hairy, which insulates against the cold and provides a grip on icy surfaces.

∽

The museum purchased four mammal groups in succession over four years, the Arctic group being the third, and at £100 the largest and most expensive. Transporting the exhibits halfway around the world from Britain could have been prohibitive, but the Shaw Savill Line—shipper of numerous immigrants to New Zealand, including myself in 1961—came to the party by carrying the Arctic group free of charge. It arrived safely in 1906.

The exhibit was three and a half metres long but the diorama base was in three sections: it had been specified that each mammal group had to come knocked down in sections not exceeding four feet (1.2 metres) wide so they could fit through the museum's main entrance door. It was installed in the centre of the exhibition gallery so it could be viewed from all sides, with the section joins hidden by powdered gypsum covering the floor of the display to resemble snow. According to the museum's annual report for 1905–06 the mammal groups had "attracted considerable attention" and

contributed to an increase in annual museum visitor numbers to 61,000.

Around 1929 the Arctic group was moved from the museum's Princes Street building to the new war memorial building in the Domain, where it was exhibited in various galleries until the late 1990s. It was then moved into storage, awaiting a return in 2002 for the museum's 150th anniversary exhibition. Today it occupies a temporary position in the Children's Weird and Wonderful Discovery Centre.

The polar bear and musk oxen are, apart from some fading, in excellent condition, and still together as a habitat group on their original bases. There is perfect realism in the animals' poses, and an excellent finish, particularly in their faces. The elegance and dynamism of the group, viewed from any angle, is still as pleasing as it must have been to the public in 1906. Surviving examples of high-quality taxidermy like this are precious.

The museum's three other mammal groups—a male lion, a female lion and four cubs, two tigers and a leopard, and a South African quartet comprising a zebra, waterbuck, springbok and impala—have not survived.

Among old photographs of museum interiors in the 1920s there is one with a small but tantalising end-on view of the tiger group. In all my years at the museum I had found no reference to the tigers' fate, nor even clear images or descriptions of the animals, when suddenly in 2008 Martin Collett, the museum's manuscripts librarian, found a cutting from an old illustrated newspaper that he thought might interest me. It included a stunning photograph of the lost tigers, one crouching and

snarling, the other standing upright on a slight rise and looking out into the distance. The caption described them as "Tigers from the Deccan, central India".

ORANG-UTAN
(SIMIA SATYRUS, L.)
Adult Male, collected near Sandakan, N.E. Borneo.

The Orang-utan is found only in Sumatra and Borneo, inhabiting dense forests in the lowlands. Although possessed of immense strength, it is sluggish in its habits, and rarely attacks man, unless surrounded and its escape cut off. It spends most of its time among the branches of lofty forest trees, and is seldom seen on the ground. Its food is composed of fruits, succulent branches, and leaves.

It is one of the anthropoid, or man-like, apes, and is very closely allied indeed in its general structure to man. It differs chiefly in its hairy covering, in the projecting jaws, in the great length of the arms, in the imperfectly formed thumb, and in the prehensile foot.

Charles Adams' orang-utan

In 1890 a steamer brought a cargo of stuffed animals to Auckland. Among them was an orang-utan (*Pongo pygmaeus*), a hairy reddish-brown great ape from the rainforests of Sumatra and Borneo and one of our closest cousins in the evolutionary tree of life. Thomas Cheeseman, curator of Auckland Museum, was pleased with the animals' good condition. Pending construction of a display case, he placed them in the museum's lecture room. He wrote to the taxidermist, reporting that he had heard "nothing but praises of the manner in which they are mounted".

Most of the visitors who saw the stuffed animals in the museum's small Princes Street building would have seen nothing like them before. They would have marvelled at the orang-utan's human features, whether or not they knew its name is Malay for "man of the forest". Orang-utans, adapted for a life in the trees, have the longest arms of any apes, and the stuffed one, an adult male with expanded cheek flaps, was mounted with one arm raised.

The taxidermist was a young American named Charles Adams. Adams was born near Champaign, Illinois, in

1857. He studied taxidermy at the University of Illinois and later worked at Henry Augustus Ward's well-known Natural Science Establishment in Rochester, New York. Ward's continues today as a biological supply house for educational institutions and museums, and its catalogue of specimens and materials is the thickness of a large telephone directory.

In about 1881 Henry Ward visited Auckland, where he met Cheeseman and learned the museum was having difficulty obtaining the services of a taxidermist. No skilled taxidermist was available locally, and many new-found specimens—such as unusual birds and trophy fish of record-breaking size—were going to waste. Ward undertook to help find the museum an American taxidermist, and by 1884 arrangements were set. The man's arrival in Auckland was eagerly anticipated until word came that he had died. Another had to be selected, and this was Charles Adams.

Adams reached Auckland in January 1885. Cheeseman liked him very much, finding him "a fair workman, very attentive to his duties, and a nice quiet fellow into the bargain". In the first year, Adams probably spent most of his time mounting local birds newly brought to the museum, and foreign birds and mammals that had been received in recent years in an unfinished state. He then travelled to collect material in the Auckland area, and further afield to Pirongia in the Waikato, Cuvier Island off Coromandel Peninsula and Karewa Island in the Bay of Plenty.

In 1886, the museum used Adams' skills in pioneering attempts to go beyond individual animals in glass cases: it produced two small "habitat groups"—or, as they are

known today, dioramas. This was less than ten years after the first museum displays showing natural history specimens in their natural contexts appeared in Britain and the United States.

One Auckland habitat group was in a wooden case, on legs, with a glazed front about one and a half metres wide, and depicted burrow entrances shared by shearwaters and tuatara on an offshore island. The tuatara (*Sphenodon punctatus*) is a large lizard-like reptile unique to New Zealand and one of the animals that puts New Zealand on the map zoologically.

Living reptiles of the world are divided into four orders and the tuatara is the sole representative of one of them. (The other three orders are turtle-like animals, crocodiles and their kin, and the closely related snakes and lizards.) On suitable islands, tuatara benefit from seabirds: they may shelter in the birds' burrows (although they can excavate their own), eat the insects that thrive in the guano-rich soil, and devour an occasional chick. There is no benefit to the birds from the presence of the reptiles.

The other of Charles Adams' dioramas showed a ravine in the Southern Alps. Some examples of New Zealand's alpine parrot, the kea (*Nestor notabilis*), were pecking at a dead, bloodstained lamb. The propensity of these large intelligent parrots to attack lambs and sheep had become popular knowledge and led to their persecution. Today we accept that their impact on sheep is fairly minor compared with other causes of sheep loss to the farmer: attacks are largely confined to sheep that are sick, injured, or stuck in mud or snow.

Graham Turbott, a long-time curator at Auckland Museum and later the museum's director, suspected the kea diorama, which he remembered from his childhood, sent a thrill of horror through Auckland's Victorian children, and that many a sobbing girl or boy must have been taken home by shaken parents. The case was dismantled, probably in the 1930s, perhaps in the hope of mending the kea's reputation.

Early in 1887 Adams left Auckland. Cheeseman wrote to a zoologist, "I am sorry that my present assistant, Adams, cannot see his way to remain, for he is a really good all-round man—both in taxidermy, osteology and modelling."

Adams journeyed south to Dunedin and reported to Cheeseman by letter on what he saw. The Colonial Museum in Wellington was "not well advanced in a zoological direction" and things were "not nicely arranged and gotten up". At Canterbury Museum in Christchurch there was a large and valuable collection, but he was again disappointed with the animals. The museum was "not nicely kept": "old labels are left tied to the legs of birds and the mounting is not good". Dunedin's Otago Museum, where there was a large zoological collection pleasingly arranged in wall cases and the specimens were well done and well kept, was the one he liked best.

Adams was held up at Port Chalmers in Dunedin for three days while the SS *Mariposa* had a new propeller fitted. When it finally sailed for Sydney the steamship company gave the passengers the consolation of calling in at Milford Sound.

In Melbourne, Adams met a young man who had been three years in British North Borneo, now Sabah, Malaysia. He decided to go there armed with letters of introduction

to the young man's friends and the governor. From the capital, Sandakan, he planned to collect bird and mammal specimens, which he would prepare and sell to museums. Cheeseman was one subscriber, in December 1887 making a transfer of £50 to Adams via a bank in Singapore.

∞

By 1888 Adams had safely returned to the United States. Meanwhile, skins of Bornean mammals had been sent to Auckland, unfinished, in a cask of brine, and arrived after long delays. With again no taxidermist, Cheeseman had to consider sending the skins overseas to be mounted and asked Adams if he would do the work back in Champaign. In letters, he gave Adams many instructions on how the mammal skins, particularly that of the orang-utan, should look. Finally, the finished mounts were shipped to Auckland from Adams' workshop, and in 1890 Cheeseman wrote to acknowledge safe receipt. The total bill came to £47.11.3, with unexpected shipping costs adding another £29. By the end the orang-utan skin was much travelled—from Sandakan to Auckland, and from there to the United States and back again.

Amid the praise for Adams' skilful work, Cheeseman had just one criticism—"Would it not have been better to have shewn the teeth of the orang?"

Adams responded, "The lips of an orang-utan are so exceedingly thick that, to me, an open mouth is a disgusting sight, and besides I could not think of a natural excuse why the animal should have its mouth open." He had

replaced the skull with a wooden substitute, into which he could nail winged wooden sides to provide firm support for the protruding cheek flaps.

Auckland Museum's mammals from Borneo were placed in a new case specially erected in the centre of the main hall. The annual report declared them to be in many respects the most important acquisition for several years. The orangutan boasted a label beautifully printed in gold lettering on thick dark-brown card with a bevelled gold edge. Auckland Museum had around a hundred visitors on weekdays and two hundred on Sundays, and the Bornean mammals helped delight and educate the public.

Charles Adams was now supplying his work to several public museums in America and anticipating a successful career as a celebrated taxidermist. He told Cheeseman that, despite a tendency to suffer badly from seasickness, he was thinking of taking another tour of the world, and also thinking of a trip within the United States to collect skins of large mammals. In 1891 he joined a six-month expedition to the Galápagos Islands and was afterwards engaged by the Illinois State Laboratory of Natural History to install bird exhibits in the state's display at the Columbian Exposition, held in Chicago in 1892 and 1893. He ended a letter to Cheeseman with the hope that Cheeseman would come to the Chicago World Fair and allow him the chance to entertain him.

It was not to be. Adams, aged thirty-six, died suddenly in May 1893 from "congestion of the brain"—probably meningitis or encephalitis. An obituary described him as "a zoological collector of wide experience and a superior

taxidermist ... a man of sterling qualities [whose] frank, genial, and modest disposition won enduring friendships for him wherever he went".

About 1928 Charles Adams' orang-utan moved from the Princes Street building that Adams had known to the grand new building on the hill in Auckland Domain. When I started at the museum in 1982, it was in a large corner case devoted to primates in a natural history gallery. Today these galleries are devoted entirely to New Zealand material. The much-travelled orang-utan from Sandakan, prepared by the well-liked taxidermist from America, resides in a social history gallery celebrating childhood.

The mystery of the banjo frogs

Most enquiries from members of the public are of only transitory interest but occasionally they can be momentous. So it proved when my telephone rang in October 1999. A young man said he had found some unusual tadpoles. He was familiar with the common tadpoles in the Auckland area that belonged to the introduced green and golden bell frog, *Litoria aurea*. The ones he had were different and he felt someone should know about them.

Three species of Australian frogs were deliberately established in New Zealand in the late nineteenth century: two large green species—the green and golden bell frog and the southern bell frog, *L. raniformis*—and the small brown whistling frog, *L. ewingii*. These are the frogs New Zealanders are most likely to encounter: they call noisily during the breeding season and produce tadpoles. However, the native frogs are seldom seen. Of the genus *Leiopelma*, they are restricted to a few forested parts of the northern North Island and to some small islands in the Marlborough Sounds. They have no loud breeding calls and their eggs hatch directly into tailed froglets without a tadpole stage.

I asked the caller to bring in a few tadpoles so I could see them for myself. At the appointed time he arrived, placed a container of water on the bench in my workroom, and opened it up. The tadpoles were certainly not the pale, uniformly coloured ones I was used to. As they swam about, there was an indication of a faint pattern of blotches on their dark upper surfaces, and their body shape was different.

I asked if I could raise some of the tadpoles into froglets to see what developed. Later that day I blanched some lettuce leaves in boiling water to serve as tadpole food. As the tadpoles grew it was soon clear they were turning into brown-coloured froglets and not the green ones to be expected. I advised the finder that I was going to ring the Ministry of Agriculture and Forestry's biosecurity hotline.

The ministry's telephonist took my details and I was very promptly contacted by Davor Bejakovich, a herpetologist at the ministry. Bejakovich asked me to send preserved samples to Michael Tyler, a frog expert in Adelaide: all indications were that the frog was an Australian species not previously recorded in New Zealand. After Tyler had studied the specimens and photographs, he advised us we were dealing with the banjo frog *Limnodynastes dumerilii*. A laboratory in Queensland later analysed DNA from the samples, confirmed this identification, and found the New Zealand specimens belonged to a subspecies of banjo frog that inhabited coastal New South Wales.

Soon after I sounded the alarm, field investigations—a "delimiting survey" as it is known in biosecurity circles—began. I joined Bejakovich and another herpetologist, Tony Whitaker, as they visited the house of the young man who had discovered the tadpoles. As a form of supplementary income the man collected and raised frogs and tadpoles to sell to pet shops. In the garden of his parents' home there were a series of large, free-standing aquariums containing hundreds of tadpoles.

He told us he had collected spawn of the mystery frog at a remote bush-clad stream on the road to Whatipu, an isolated beach in the Waitakere Ranges west of Auckland city. We all travelled to the site and a search of the stream revealed further tadpoles, and two emerging from the water as froglets. Next day torrential rain scoured the creek, and on subsequent inspections ministry staff found no more tadpoles or frogs. The existing tadpoles and froglets were destroyed and the aquariums at the man's home sterilised with sodium hypochlorite.

In the following months, staff from the ministry, the Department of Conservation and Auckland Regional Council searched likely sites across west Auckland. At night they listened for the banjo frog's loud and distinctive "bonk" calls, which are nicely evoked by the creature's other name, pobblebonk. Recorded frog calls from Australia were played to see if there was any response.

Michael Tyler was brought to New Zealand to view potential habitats for the frog in Auckland and advise on the likelihood of its establishing there. The news was not encouraging: there seemed a good chance the frog could

survive where there was suitable habitat. As an aggressive and reasonably large predator it might then eat, or compete for food with, certain native animals, with detrimental impact on the environment.

I killed and preserved some of the banjo frog tadpoles and froglets at various stages of growth so Auckland Museum would have a good range of reference samples against which to compare any future suspicious tadpoles. While on holiday in Fiji, I also took the opportunity of collecting samples of the dark tadpoles of the introduced Central and South American cane toad *Bufo marinus*, which is a serious pest in several Pacific countries and a significant threat to native species in northern Australia. Cane toads were once brought live into New Zealand as laboratory animals, and have been found alive in cargo arriving in the country. In 1997 I was given a specimen for the museum: it had been found hopping about in a South Auckland ditch near a cargo warehouse.

∽

It appeared the banjo frog had been deliberately introduced: spawn, or perhaps tadpoles, had been smuggled in from Australia. To this day it remains a mystery as to who did this and why the spawn was placed at such a remote and unlikely location. No further banjo frogs were found in west Auckland in 1999 or during monitoring over the next two years, and none has been reported since.

Accidental introduction of pest animals is as much a hazard as deliberate introduction. With Davor Bejakovich and Tony Whitaker, I embarked on a study of the potential

for amphibians and reptiles to arrive by accident in cargo coming into New Zealand. We compiled records of interceptions of foreign species, based on specimens in museums and records held by the Ministry of Agriculture and Forestry. For the period from 1929 to 2000 we were able to document more than fifty species of frogs and reptiles among 189 incidents: most were from Australia, south-east Asia and the south-west Pacific. In more than eighty percent of cases animals were alive when detected, and nearly half the animals were intercepted after the cargo had passed through border controls. This showed the importance of having reference material in museum collections to help biosecurity officers quickly and easily identify unknown animals—the first and fundamental step in any action against an unwanted intruder. Interestingly, despite the potential for accidental introduction, only one frog or reptile—the Australian rainbow skink *Lampropholis delicata*—has so far established in this way in New Zealand.

Captain Cook's tortoise

One of Auckland Museum's more esoteric claims to fame is that it is mentioned at the beginning of Philip K. Dick's classic 1968 science fiction novel *Do Androids Dream of Electric Sheep?*—the book that inspired the 1982 Hollywood movie *Blade Runner*. The novel begins with a dispatch from Reuters news agency, dated 1966, reporting that the tortoise Captain Cook gave the King of Tonga in 1777 had just died at the age of nearly 200 and its body would be sent to Auckland Museum in New Zealand.

A tortoise named Tu'i Malila that lived in the grounds of the Royal Palace at Nuku'alofa did indeed die in May 1966, and at the request of the Tongan Government was sent to Auckland—frozen and presumably by sea—to be stuffed.

When it arrived the museum's preparator, Leo Cappel, set about the laborious task. He had to remove the tortoise's flesh and internal organs, clean the skin and carapace—the domed shell—and put inert material in place of what had been taken away. A framework of connected internal rods was needed to strengthen the attachment of head and limbs. Then, while the skin was still soft and supple, it had to be

sewn up and the animal arranged in a life-like position before it dried rigid. It was a big job on such a bulky animal.

During the preparation Joan Robb, a reptile specialist at Auckland University's zoology department, examined the body, and with the help of books and articles determined it was a radiated tortoise native to southern Madagascar. Its carapace was about forty-one centimetres long and twenty-four centimetres high, full-sized for the species; its weight would have been about thirteen kilograms.

According to Tongan tradition, James Cook presented a pair of tortoises to a chief in the Ha'apai group in May 1777, during his third voyage to the Pacific. However, Cook would almost certainly have recorded such an important chiefly presentation in his journals and there is no corroboration there, which casts some doubt on the matter. The chief is said to have given the tortoises to the Tu'i Tonga, or king, as a plaything for his daughter at Mu'a on the island of Tongatapu. The female tortoise eventually died and the male passed into the care of Catholic priests and nuns until 1920, when it was transported to the main town of Nuku'alofa, presumably to take up residence in the palace grounds.

If it were indeed presented by Cook (or another officer or seaman) on that voyage, Tu'i Malila would have been at least 189 when it died. Even if it had come to Tonga during the period of whalers and traders in the early 1800s, or later, in the mid 1800s, it was still at least a century old. Its dented and scarred carapace testified to its great age, and to the trials and tribulations of its long residence in the "Friendly Islands", which included being kicked by a horse and run over by the wheels of a dray. The tortoise had also

gone blind, and hampered by this impediment had wandered into a grass fire in the palace gardens and been badly singed.

Tu'i Malila was a great curiosity for dignitaries visiting the Tongan royal family. Admirers included Queen Elizabeth and Prince Philip during their 1953 Commonwealth tour and the governor general of New Zealand, Sir Bernard Fergusson, on an official visit in 1964.

During taxidermy the sex of Tu'i Malila could not be determined from internal organs because the soft tissues had deteriorated before the body reached Auckland. However, the plastron, the section of shell covering the belly, was flat, suggesting Tu'i Malila was a female, not a male as had always been thought: male tortoises have a concave plastron to facilitate the juxtaposition of their shell with the shell of the female during copulation.

The taxidermy job completed, Tu'i Malila was exhibited in Auckland Museum for a while before being shipped back to Tonga, where it was displayed in the lobby of the International Dateline Hotel in Nuku'alofa.

In 1988 I went to Tonga for fieldwork and chanced upon Tu'i Malila in a display case at the new Tongan National Centre. It was not a pretty sight. The head and a limb or two had fallen to the floor of the case, insects had damaged the skin and stuffing was tumbling out. Just as sad were the robes that Sālote Tupou III, the Tongan queen from 1918 to 1965, had worn to Queen Elizabeth's coronation. These were upright on a mannequin in a tall case but were peppered with large holes, as if they had been raked up and down by heavy machine-gun fire. The holes were presumably the work of insect larvae when the robes had been folded away in storage. The tropics are a

difficult environment for many museum objects. In New Zealand "borer" beetle larvae make pinhead-sized holes in wooden framing and furniture, but at Nuku'alofa the dining table in the house where I stayed had woodworm holes into which you could poke a pencil. It was no doubt these sorts of larvae that had played havoc with the queen's robes, and something similar had eaten away at Tu'i Malila's skin.

The state of the tortoise eventually led to its return to Auckland in 1997. This time things were not so easy: Tu'i Malila was impounded for two months at Auckland Airport pending fumigation, issuing of agricultural quarantine permits, and production of paperwork to clarify its position under CITES (Convention on the International Trade in Endangered Species) regulations. After Auckland Museum conservators finally took delivery of the tortoise and assessed its condition, a preparator undertook remedial work to make the tortoise again presentable for display in Tonga.

Tortoises are renowned for their longevity, and some individuals have lived so much longer than humans it has proved difficult to keep accurate records of just how old they are. A tortoise taken from the Seychelles to Mauritius is thought to have lived at least 152 years, and another in the garden of the residence of the governor of Saint Helena may have lived more than 175 years.

A Galápagos giant tortoise named Harriet died in 2006 at a zoo in Queensland, Australia. It had supposedly been a passenger on HMS *Beagle* with Charles Darwin. Because England had been too cold for the tortoise, it was said to have been sent to Brisbane in 1842. DNA tests showed that the zoo's Harriet belonged to a population from the

Galápagos island of Santa Cruz, which the *Beagle* never visited, but that did not stop a celebration of her 175th birthday taking place in 2005. Another Galápagos giant tortoise, Lonesome George, who lives at the Charles Darwin Research Station on Santa Cruz and is the last survivor of his race from Pinta, a remote island in the Galápagos group, is thought to be between sixty and ninety years old.

∾

During my 1988 visit to Tonga, in a display of old photographs at the Tongan National Centre I saw a picture of a man standing astride a tortoise that seemed much larger than Tu'i Malila. At that time, Tongan friends got me entry to a feast in the royal palace grounds, where I was surprised to see a small tortoise wandering about. All this raised the question of just how many Tu'i Malilas there had been. I wrote to the Tonga Traditions Committee and received a copy of a newspaper clipping showing that the small tortoise was a gift to the king, Tāufa'āhau Tupou IV, from America's National Geographic Society. A senior editor, while visiting Tonga, had seen Tu'i Malila, identified the species, and arranged for another individual to be sent by sea from Madagascar to the United States. From there it had been flown to Tonga, arriving on a Fiji Airways plane.

The tortoise was intended to be a mate for Tu'i Malila but alas it arrived in September 1966, four months too late. At the opening of the International Dateline Hotel soon afterwards, the king had the new tortoise brought along. In the presence of a large gathering he named it Tu'i Malila II.

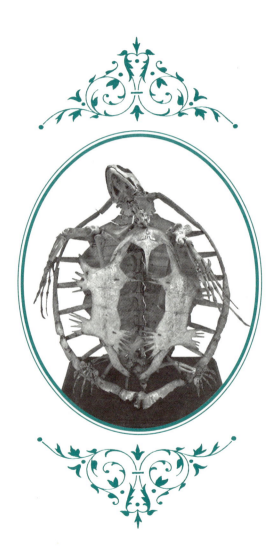

Turtle bones

Wonderful things wash up on beaches. In September 1996 a woman found a large dead turtle on Waikorea Beach, an isolated spot west of Hamilton in northern New Zealand. She reported it to the local office of the Department of Conservation. Two officers, Laurence Barea and Gary Hickman, went to investigate. They took photographs of the turtle, then buried it in nearby sand dunes and marked the spot.

Turtles, with their protective armoured carapace and plastron—upper and lower halves of the shell—are distinctive animals, superbly adapted for their marine existence. They have a streamlined body and their forelimbs have evolved into large propulsive paddles. In the fossil record as far back as 200 million years there are creatures we would immediately recognise as turtles if they were alive today. The shape of the turtle's body is so successful it has proved remarkably stable in evolutionary terms: modern turtles have changed very little from their earliest ancestors. Only the destructiveness, greed and indifference of people threaten the turtles' future—as they do our own.

Turtles breed in the tropics and are widely distributed in tropical and subtropical seas. Occasionally they turn up in colder regions, including the seas around New Zealand, where five species have been recorded. Here they are most commonly seen in summer and autumn, in the warmer northern half of the North Island. Most are stragglers, assisted or carried by the East Australian Current, which flows south along Australia's east coast, east across the northern Tasman Sea, then south-east along the edge of the continental shelf off the north-eastern North Island. Roughly seventy percent are alive when found, but many have become entangled in nets or lines. Others are washed ashore, a sign of illness or cold-shock: normally they would come ashore only to lay eggs and none can breed so far south.

Commonest in New Zealand is the leathery turtle *Dermochelys coriacea*. It is the largest of all living turtles, reaching around three metres in total length and weighing up to 900 kilograms. The carapace is a mosaic of small, many-sided bony plates covered in tough skin. It has seven longitudinal ridges: swimming at the surface the turtle looks like an upturned dinghy.

The leathery turtle is the world's most widely distributed turtle, found in all tropical and temperate seas. It is the only species widely reported in southern parts of New Zealand because it deliberately seeks out temperate waters as feeding grounds. It can do this through physiological adaptations that enable it to maintain a higher core body temperature than the ambient temperature. The four other turtles recorded in New Zealand—green turtle, *Chelonia mydas*, loggerhead turtle, *Caretta caretta*, hawksbill turtle,

Eretmochelys imbricata, and olive ridley turtle, *Lepidochelys olivacea*—are smaller and their carapaces, featuring large juxtaposed scaly scutes, are more typical. These turtles mainly turn up in northern New Zealand waters that, even in the far north, are too cold for them most of the year.

∽

The body of the turtle at Waikorea Beach was in an advanced state of decay. One of the rangers sent me photographs and asked for an identification. I could see the carapace's individual scutes, including the row running along the midline, and the marginal scutes along the edges of the shell. Between these on each side was a row of five, possibly six, of the large scutes known as costal shields. The green turtle and hawksbill have only four pairs of costals, the loggerhead has five (rarely six) and the olive ridley has six. I felt the dead turtle was most likely to be a loggerhead since there were numerous records of this species in New Zealand, whereas the olive ridley had been recorded only twice.

The photographs were later seen by Raymond Coory at the Museum of New Zealand Te Papa Tongarewa. He noticed the carapace was diamond-shaped and felt it was very similar to the carapace of an olive ridley in the Te Papa collection. I sent photographs to a colleague at the Smithsonian Institution and these were seen by two other American specialists familiar with olive ridleys. All agreed that from the look of the animal it was an olive ridley.

More photographs of the Waikorea specimen then emerged. Shots of the underside showed the presence of

four "inframarginal" scutes—the row of shields on each side of the plastron between the forelimb and hindlimb and next in line beside the marginal scutes. The olive ridley has four inframarginals, whereas the loggerhead usually has three. The Waikorea turtle was, therefore, a particularly interesting specimen—only the third known record of an olive ridley in New Zealand. The first had been found at Flat Point in the Wairarapa (North Island) in 1956; the second at Kaka Point Beach near Dunedin (South Island) in 1985. Olive ridleys are distributed throughout the tropics, but are most abundant in the eastern Pacific Ocean, the Indian Ocean and the Gulf of Guinea in the Atlantic.

About a year and a half after the turtle was buried, the Department of Conservation officers returned to exhume the bones. After successfully recovering the entire skeleton they kindly delivered it to Auckland Museum. The turtle had measured about 700 millimetres along the curve of the carapace, and as it was an adult its bones were fully grown and ossified. The time in the damp sand had cleaned the bones beautifully, and all Maree Johnston, the land vertebrates technician, had to do to prepare them for the collection was to wash and scrub them gently and set them out to dry. Bones in a museum collection need to be clean so it is possible to examine the bones' minute features, and so no dried tissue that could attract and sustain insect pests remains. Moth and beetle larvae that eat dried flesh in the wild and clothing and carpet fibres in people's homes will eat fur, feathers and fibre on objects in museum collections.

Skeletonisation of a fresh corpse to obtain clean bones is a time-consuming process. We normally use the simple

technique of cold-water rotting. The skin, internal organs and larger muscles are removed with scalpels, and the remaining body boiled briefly to improve the subsequent rotting process. It is then placed in a vessel of cold water with the lid on. Bacteria flourish, destroying the soft tissues. The water in the jars and buckets is changed several times over the following months until clean bones are visible. After disinfection with bleach, scrubbing of any troublesome areas and final rinsing, the bones are carefully picked out and set aside to dry. Not all aspects of the task are pleasant, but the redeeming feature is the set of beautiful clean white odourless bones produced at the end.

Larger animals rotting down in large buckets generate a lot of liquid for disposal, so for a couple of wallabies, an albatross and a mute swan I tried out my compost bin at home. Ramola Prasad, the technician, fleshed out the body and had it wrapped in newspaper so I could take it straight home from the freezer one day after work. I had a hole ready in a bin of friable, well-rotted compost. I buried the package, kept the bin moist for six to twelve months, and then dug out the bones. If the neighbours ever saw me burying and exhuming strange items they never mentioned it. The bones needed a lot of scrubbing, but the end results were worthwhile.

Many large museums use colonies of dermestid beetles to clean bones. The beetles' larvae eat the surrounding tissue but leave the bones alone. For best results the animal bodies are again roughly stripped down, and this time dried before exposure to the beetles. The process takes time, and the beetle colonies need constant maintenance to keep the temperature, humidity and supply of food just right.

In addition, precautions are needed to prevent the beetles escaping into the museum collections: usually the colony is kept in a separate building or outhouse.

The Waikorea turtle bones, already fully rotted down in the dunes, were therefore a great gift. Using indelible ink, Maree Johnston wrote the registration number on as many as possible and painted over each number with a clear acrylic solution to protect it. Stored loose in a large box, the bones then joined the museum's collection, ready for service in research studies, identifications and exhibitions.

At least two archaeologists, studying bones from prehistoric midden sites in the tropical Pacific, have used the Waikorea bones as reference specimens, to help determine which of many bones and bone fragments found in the middens belonged to turtles. The skull was once displayed in a temporary exhibition, and I have used the bones to help describe a forty-million-year-old turtle fossil.

Jane Hill, a secondary school teacher, had found this fossil in 2005 at a roadside cutting near Whangarei in northern New Zealand. Jack Grant-Mackie, a retired geologist still active at the University of Auckland, helped recover the fossil bones and asked me to assist in the study of them.

The fossil represented a large turtle with a carapace approaching 900 millimetres long, and was from the Late Eocene Epoch—that is, forty to forty-five million years ago. It comprised a broken right humerus—an upper forelimb bone; some bones of the right "hand"; five vertebrae, preserved in line as in life; and various other fragments. The bones were broken, incomplete, and in places still partly obscured by hard rock, but each had to be identified as to which part of

the skeleton it was from, and compared in shape and size with published descriptions of fossil turtles from around the world.

The string of vertebrae was difficult to place. Fortunately, in 1879 the museum had received on exchange from the Royal College of Surgeons in London an articulated skeleton of a green turtle. Still extant, the skeleton was mounted vertically with the head pointing skyward and the belly facing out. The carapace was supported on a metal rod and all the other bones were wired into their correct positions. Guided by this green turtle skeleton and the loose bones of the Waikorea turtle, I finally pinned down the fossil vertebrae as cervical (neck) and thoracic: C6, C7, C8, T1 and T2.

∽

The Eocene turtle from Whangarei is an important record of New Zealand's fossil history. The immense age of fossils is hard to grasp, but various analogies help us to understand the enormity of geological time. One is to consider the age of the Earth compressed into a calendar year that began on January 1 and in which the current time is midnight on December 31. It took a long time for the planet to develop conditions favourable to living organisms—the first simple forms of life appeared around the beginning of June. The dinosaurs reigned from December 13 to 26. The Whangarei turtle fossil seems very old at forty million years, but was in fact living quite recently, on about December 28. Humans, in case you were wondering, appeared on December 31 at 11.50 pm, and the whole of recorded human history has taken place in the last forty seconds before midnight.

The Aitutaki house geckos

In October 1995, when I visited the tiny Pacific island of Aitutaki in the Cook Islands, I went out on foot at night to look for geckos in the main village, Arutanga. I was doing a survey of reptiles in the islands and collecting voucher specimens for Auckland Museum.

The evening was warm and humid, I could smell the scent of tropical flowers and there were the sounds that typify a Pacific island settlement: barking dogs, bleating goats, snuffling pigs and the ever-strident crowing roosters. It was thirsty weather, so I called into the Seabreeze bar on the wharf for a few beers. The intake of liquid soon had me in the lavatory, which was lucky for on the walls near fluorescent lights I caught three geckos.

I was not immediately sure what species the geckos were, as many geckos appear very similar. But however similar they may look at first glance, their differences are often reflected—strange as it may sound—in the number, size and shape of the pads, or lamellae, along the underside of the toes.

Toes are very important to geckos. Batteries of microscopic hairs on the lamellae beneath the flattened and

expanded toes of many kinds of geckos enable these lizards to climb along walls and ceilings. The microscopic hairs connect to the surface by inter-molecular forces to give dry adhesion. As the gecko rolls and unrolls its toes against the surface, countless connections are made and broken at the submicroscopic level. Altogether, over the area of the expanded toes, these tiny connections are enough to support the gecko's weight. Today geckos' toes are closely studied by bioengineers looking for new and improved artificial adhesive mechanisms.

Because herpetologists need to pay such close attention to toes when identifying geckos, the descriptive generic names of many geckos end in "dactylus", from the Greek "daktylos" referring to the finger. I used a hand lens to look closely at the pattern of scales on the head and toes of the geckos from Arutanga wharf and this confirmed my suspicions that they were the Asian house gecko, *Hemidactylus frenatus*.

༄

Geckos are one of the largest families of lizards and one of the most widespread, being common throughout the warmer regions of the world. Their body scales are small and granular, giving their skin a dull velvety appearance. Geckos have large eyes that they cannot blink: in the course of evolution the lower eyelid has fused shut. In compensation, one transparent scale on the eyelid has enlarged to cover the eye. This scale is shed and renewed regularly, along with the rest of the gecko's skin. If the eyes get dirty between moults, the gecko licks them clean with its large fleshy tongue.

In the tropics, various species of geckos enter dwellings as "house geckos", emerging at night to feed on insects attracted to electric lights. Most reptiles are silent but geckos are an exception: some species, including many house geckos, have chirping or chattering calls.

The main house geckos in the South Pacific islands are the oceanic gecko, *Gehyra oceanica*, the sad (or mourning) gecko, *Lepidodactylus lugubris*, the fox gecko, *Hemidactylus garnotii*, the stump-toed gecko, *Gehyra mutilata*, and the Asian house gecko. These geckos form an interesting case study in biogeography—the study of the distribution of organisms and the mechanisms by which the patterns of distribution have arisen. The oceanic gecko readily enters houses but it also lives happily in forests, away from dwellings. It is found nowhere else but the Pacific so is probably native to most of the many Pacific islands where it lives, and pre-dates the arrival of humans. It is a forest gecko that enters houses opportunistically.

The sad gecko is found on islands throughout the Indian and Pacific Oceans. In the Pacific it lives in the bush as well as in buildings. Sad geckos presumably spread across the Pacific either naturally before human settlement—eggs or adults rafted between islands on debris—or were spread by the canoes of the early Polynesian voyagers as they moved out of south-east Asia to colonise the Pacific. Ancestral Polynesians reached Samoa and Tonga about 3,000 years ago and then spread east, perhaps with sad geckos as stowaways.

In the Pacific, the fox and stump-toed geckos, natives of southern Asia, are usually restricted to human habitations,

the sign of an introduced species. In Polynesia, the fox gecko tends to live mainly in rural villages, suggesting it may have been introduced early—with Polynesian voyagers perhaps, or by sailing ships in the 1800s. The stump-toed gecko is fully at home in Polynesian towns and possibly arrived a little later. It is not called *Gehyra mutilata* for nothing, for if it is roughly handled it self-mutilates as a defence mechanism. It does not just shed its tail, as many lizards do, but can also slough off entire sections of skin, leaving areas of exposed slippery flesh, reminiscent, on a smaller scale, of raw skinned chicken meat. This is as disconcerting to the field herpetologist who catches these geckos as it must be confusing to the small predator.

The Pacific house geckos lay eggs that, when insinuated into crevices in cargo, are easily transported about. Many have sticky eggs that become cemented into cracks as they dry. The fox and sad geckos have another attribute that has aided their spread between islands: they exist as asexual clones that reproduce by "virgin birth", known technically as parthenogenesis. This means only a single egg or individual is needed to found a new population. All individuals are females. Conveniently bypassing the need for any males, they lay unfertilised eggs that hatch into females. The individuals of these clones have limited genetic variation because this can happen only by mutation, not by the reassortment of parental genes that occurs in sexually breeding species.

Parthenogenesis is unsurprising in insects and is known in some fish, but it is fairly rare in reptiles and unknown in birds and mammals—the higher vertebrates. (There

has been one case reported in our own species, in the eastern Mediterranean some 2,000 years ago at a town called Bethlehem. Regrettably the biological details of this remarkable birth are unknown since the accounts are purely anecdotal.)

Parthenogenesis in lizards was first discovered in the 1950s by Ilya Darevsky, a zoologist at the Leningrad Academy of Sciences, who found that certain populations of a lizard in Armenia seemed to be entirely female. Darevsky's published results were doubted until the 1960s, when American herpetologists found all-female populations of whiptail lizards in the south-west United States and some of these lizards demonstrated parthenogenesis.

It is now thought that about one percent of the world's 3,000 species of lizards are unisexual. Parthenogenetic lizard clones have mostly arisen suddenly, as the freak but functioning offspring of a rare and chance hybridisation of two different species.

The Asian house gecko, the most recent gecko to arrive in the Pacific, is easily spread by the current systems of moving international freight by sea and air. It is shaping up to be a significant invasive species throughout the warmer parts of the world. Its original distribution is thought to have been South-east Asia and New Guinea. In Australia, it was found near Darwin in the 1800s, and it has since spread widely throughout northern Australia. The first specimens in Brisbane were collected in 1983 and it is now the commonest

gecko in that city. It is found in and near most Queensland ports from Cooktown to the Gold Coast, and in coastal New South Wales south to Coffs Harbour.

The Asian house gecko established itself at Acapulco in Mexico around 1930, and in Hawaii in the 1950s. It has become widespread in the southern United States. In the South Pacific, it took hold on the main island of Vanuatu sometime between 1971 and 1986. In Fiji it was recorded in the Nadi-Lautoka area in 1980 and was well established around Suva and Labasa by 1986. A specimen was collected on Rarotonga, the main island of the Cook Islands, in 1987. In the Society Islands, French Polynesia, it arrived shortly before 1990. It is now the reptile most commonly intercepted in cargo reaching New Zealand, although conditions are unsuitable for these travellers to survive.

Wherever it spreads in the Pacific, the Asian house gecko often has competitive advantages over other house geckos. At lights, where house geckos congregate to feed, it usually displaces or reduces in number whatever species of geckos were visiting the lights before. By its size and aggression it easily excludes the smaller sad gecko.

At Bamboo Bungalows, the guest house where I stayed at Arutanga, three species of house geckos were in residence—oceanic, stump-toed and sad. At nearby Arutanga wharf, the key site besides the airstrip for the arrival of cargo on the island, I did not grasp immediately that the three Asian house geckos I had caught were probably the first arrivals of that species on the island, or their recent descendants. I happened to be collecting just as this invasive gecko had established a new beachhead in its steady conquest of

the Pacific. The existing house geckos of Aitutaki were in for a shake-up.

In July 2000 Tony Whitaker, a New Zealand herpetologist, visited Aitutaki. He found that Asian house geckos were now widespread over part of the island. He was unable to find any stump-toed geckos.

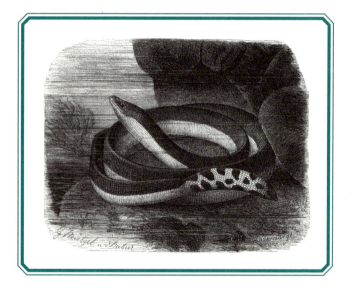

Foster Bay's sea snake

New Zealanders have a limited choice of exotic pets. While pet shops in New York, Paris and London offer gerbils, hamsters, monkeys and pythons, in New Zealand these animals are banned to prevent new species establishing in the wild and adding to the country's already long list of unwanted organisms.

As it happens New Zealand, like Ireland, is one of only a few moderately large countries that, because of their isolation as islands, have failed to be colonised by land snakes. Most New Zealanders, if asked, would count it a blessing to be in a snake-free country. The country's strict laws against exotic animal imports, together with a degree of snake paranoia, mean that even public zoos are prevented from exhibiting snakes. Not even a single neutered individual of a non-poisonous species is allowed.

Most New Zealanders, therefore, never see a living snake unless they travel abroad. When I visited curatorial colleagues at the Australian Museum in Sydney they must have thought it amusing when, despite being a professional herpetologist and a grown man, I showed child-like

eagerness for them to open up a terrarium and let me hold a harmless American corn snake they kept in captivity for use in educational programmes.

Given the dogged determination to keep snakes out of New Zealand, there exists a great irony that was brought home to me forcefully in the first month of my employment at Auckland Museum: the warmer northern end of New Zealand is host to three species of sea snakes. Carried down by currents from the tropics, these snakes occasionally wash ashore and most are alive when found.

Any snake is a frightful affront to a snake-free country, but to compound the impertinence these sea snakes would have you go a long way to find animals whose venom is more toxic. They belong to the dreaded family Elapidae or closely related families. These are the "front-fanged snakes", all of them venomous. For education the Australians import American corn snakes, belonging to the slightly more lovable family Colubridae, because so many of their own native snakes are elapids.

Not three weeks into my curatorial career, I took a telephone call about a live sea snake that had been found washed up at the high-tide mark in Foster Bay, near Huia in Manukau Harbour west of Auckland city. That was Friday. Apparently it remained alive in a plastic bucket until Monday, but it was dead when brought to me on Wednesday. It was a yellow-bellied sea snake, *Pelamis platurus*, beautifully patterned and about 630 millimetres long.

In this snake the upper half of the body is dark, almost black, and the lower half yellowish. The two colours meet abruptly at a straight line along each side. The tail is yellowish with a striking arrangement of large dark spots. The head is long, eel-like, and the snake's large mouth is filled with small needle-like teeth for seizing fish.

Sea snakes are elegantly adapted for aquatic life. Their tails are shaped like paddles and they swim like fish, with sideways, rather than up and down, movements of the tail. Between breaths, valves on their nostrils seal to prevent water entering. Land snakes have enlarged scales on their belly to help provide traction as they slither. Not needing this, yellow-bellied sea snakes have the same small scales on their belly as on their back and sides.

Yellow-bellied sea snakes became the first marine reptiles recorded in New Zealand when, in 1837, three were seen at Hokianga in Northland. Their presence is not surprising. These snakes live throughout the Indian and Pacific Oceans and are said to be the world's most widely distributed snake. They are known to breed off the coast of eastern Australia, and being truly pelagic—living in open sea—they produce live young at sea rather than laying eggs. Yellow-bellied sea snakes may be seen thousands of kilometres from land, and often congregate among floating seaweed and other debris miles out at sea. Here, or in the shadow of the snake itself, small fish seek shelter and can end up as prey.

Yellow-bellied sea snakes are weak swimmers and tend to move passively in surface currents, which is probably how they turn up in mainland New Zealand's cool waters. They are reported to cease feeding in sea temperatures below

about 18° Celsius, which means much of New Zealand is unsuitable for them most of the year. Fortunately for snake-fearers, they never come ashore unless they are sick or accidentally beached during storms: nearly all specimens recorded in New Zealand are washed up, indicating they are in distress.

On average about one yellow-bellied sea snake a year is reported to Auckland Museum or the local media. In the 1990s I began to compile records of the snakes' occurrence in New Zealand, assisted by newspaper reports going back several decades and specimens held at museums. Altogether I obtained more than sixty records, which showed the species is a relatively regular visitor to the north of the country. As the snakes escape easily from nets, those found will be only a fraction of the true number that arrive. Mostly they wash up singly, but in March 1985 four were found on Tokerau Beach in Northland.

Of thirty-nine specimens whose length was reported or that I could measure in museum collections, all were adults. They ranged from 510 to 1,155 millimetres long.

Although they are so extremely toxic and possess a big mouth—all the better to latch on to fingers—yellow-bellied sea snakes are relatively unaggressive, and if suffering cold-shock on a New Zealand beach will be in no mood to bite. They are not a significant threat to New Zealanders and the only known harm has been a persistent headache caused to legislators. Wildlife laws from the 1950s protect all naturally occurring—that is "native"—reptiles, yet our native sea snakes were overlooked when new biosecurity and organisms acts of parliament were passed into law in

the 1990s: the legislation has sanctions against all snakes, naturally occurring or otherwise. Moves are afoot to rectify this legislative conflict.

In the Chinese Lunar Calendar, 2001 was a Year of the Snake. The New Zealand postal authorities wanted a stamp issue that featured snakes and contacted me about marine reptiles. Six stamps were released; they featured four turtles and two sea snakes found in New Zealand waters. One snake was, of course, the yellow-bellied sea snake; the other was the much rarer banded sea krait, *Laticauda colubrina*, which has been recorded in New Zealand fewer than ten times. To mark the Year of the Snake the two snake stamps were also issued as a special miniature sheet highlighting Chinese symbols and calligraphy. I was glad to help promote the message that New Zealand is not quite as snake-free as people imagine.

Illustrations

Birds later used in the albatross diorama vi
Auckland Museum; photograph by Graham Turbott,
circa 1960.

Cabinet of curiosities viii
The earliest illustration of a natural history cabinet;
engraving from Ferrante Imperato's *Dell'Historia
Naturale*: Naples, 1599.

Barn owl 24
From *A Dictionary of Birds* by Alfred Newton:
A. & C. Black, London, 1893–96.

Kaikoura moa egg 32
An early depiction drawn on stone by J. Erxleben;
lithography by M. & N. Hanhart; from *Memoirs on
the Extinct Wingless Birds of New Zealand* (vol. 2) by
Sir Richard Owen: Van Voorst, London, 1879.

North Island brown kiwi chick 42
Woodcut by J.G. Keulemans, from *Buller's Birds of
New Zealand*, edited by E.G. Turbott: Whitcoulls Ltd,
Christchurch, 1967.

Albatross diorama 50
Built by Auckland Museum preparator, Leo Cappel;
photograph by Krzysztof Pfeiffer, circa 2007.

Thomas Cheeseman's first letter to Enrico Giglioli, 1877 56
Florence Museum archives; photograph by Brian Gill, 2007.

The Duke of Genoa's falconet specimen 64
Auckland Museum; photograph by Brian Gill, 2011.

Mud nest of the ovenbird 74
From *A Dictionary of Birds* by Alfred Newton:
A. & C. Black, London, 1893–96.

Rajah the elephant transformed for display, 1936 84
Auckland Museum Pictorial Collections, C23255.

The Arctic group of musk oxen and polar bear 92
Auckland Museum; photograph by Fiona Kirkcaldie, 2011.

An early display label for Charles Adams' orang-utan 98
Auckland Museum archives; photograph by Brian Gill, 2011.

Eastern banjo frog 106
Line drawing © Donna Wahl, Australian National Botanic Gardens.

Boy with Captain Cook's tortoise at the palace of Queen Sālote Tupou III, Nuku'alofa, Tonga 112
British Museum; photograph by Robert A. Lever, circa 1940s; © The Trustees of the British Museum.

Green turtle skeleton received from the Royal College of Surgeons, 1879 118
Auckland Museum; photograph by Brian Gill, 2011.

New Caledonian postage stamp with gecko 126
Courtesy iStockphoto.com.

Yellow-bellied sea snake 134
Line drawing from *Brehms Tierleben – Allgemeine Kunde des Tierreichs* by Alfred Edmund Brehm, Eduard Oskar Schmidt and Ernst Ludwig Taschenberg: Bibliographisches Institut, Leipzig, 1882–84.

Registration numbers

The specimens whose stories are told in this book are held at several museums.

Barn owl – Auckland Museum, LB1962

Kaikoura moa egg – Museum of New Zealand Te Papa Tongarewa, Wellington, ME12748

Ōkārito kiwi – Canterbury Museum, Christchurch, AV38269

Antipodean albatrosses – Auckland Museum, LB4307–8

Reef heron – Museo Zoologico, Florence, 2188

Black-thighed falconet – Auckland Museum, LB7213

Ovenbird nest – Auckland Museum, LB8051

Rajah – Auckland Museum, LM373

Arctic group – Auckland Museum, LM391 (polar bear), Auckland Museum, LM388–90 (musk oxen)

Orang-utan – Auckland Museum, LM381

Banjo frogs – Auckland Museum, LH3026 (largest froglet)

Cook's tortoise – not known

Turtle bones – Auckland Museum, LH2025 (from Waikorea Beach); Auckland Museum, LH679 (from Royal College of Surgeons); Geology Collection, University of Auckland, 18221 (Eocene fossil)

House geckos – Auckland Museum, LH1855–7 (from Arutanga wharf)

Sea snake – Auckland Museum, LH342

Further reading

"Biological messages in a bottle", Nicholas Arnold: *New Scientist 1783*, 1991.

The Bird Collectors, Barbara Mearns and Richard Mearns: Academic Press, London, 1998.

Dry Store Room No. 1: The Secret Life of the Natural History Museum, Richard Fortey: Harper Press, London, 2008.

Edward Gerrard & Sons: A Taxidermy Memoir, P.A. Morris: MPM Publishing, Ascot, Berkshire, 2004.

"Friedrich-Carl Kinsky (1911–1999)—His life and contributions to bird study in New Zealand", (S.) J.A. Bartle and J.C. Yaldwyn: *Notornis 48*, 2001.

A Gathering of Wonders: Behind the Scenes at the American Museum of Natural History, Joseph Wallace: St Martin's Press, New York, 2001.

A Guide to Model Making and Taxidermy, Leo J. Cappel: A.H. & A.W. Reed, Wellington, 1973.

"In memoriam: Ernst Mayr, 1904–2005", Walter J. Bock: *The Auk 122*, 2005.

"The Kaikoura moa egg", R.K. Dell and R.A. Falla: *Dominion Museum Records in Ethnology 2*, 1972.

Lost in the Museum: Buried Treasures and the Stories They Tell, Nancy Moses: Altamira Press, Lanham, Maryland, 2007.

"Mr Cheeseman's legacy: The Auckland Museum at Princes Street", R. Wolfe: *Records of the Auckland Museum 38*, 2001.

The Natural History Museum at South Kensington: A History of the British Museum (Natural History) 1753–1980, William T. Stearn: Heinemann, London, 1981.

"A new species of kiwi (Aves, Apterygiformes) from Ōkārito, New Zealand", Alan J.D. Tennyson, Ricardo L. Palma, Hugh A. Robertson, Trevor H. Worthy and B.J. Gill: *Records of the Auckland Museum 40*, 2003.

"Obituary—Sir Robert Falla, KBE, CMG, MA, DSc, FRSNZ", C.A. Fleming: *Emu 80*, 1980.

Ornithology from Aristotle to the Present, Erwin Stresemann: Harvard University Press, Cambridge, Massachusetts, 1975.

The Sacred Grove: Essays on Museums, Dillon Ripley: Gollancz, London, 1970.

Sea Snakes, Harold Heatwole: University of New South Wales Press, Sydney, 1999.

Windows on Nature: The Great Habitat Dioramas of the American Museum of Natural History, S.C. Quinn: Harry N. Abrams, New York, 2006.

Acknowledgements

For companionship, inspiration and encouragement in the great task of developing natural history collections, I thank the technicians and volunteers who have worked with me on the Auckland Museum land vertebrates collection, my curatorial colleagues past and present at the museum, and curatorial friends and acquaintances at other museums, both in New Zealand and overseas. It has also been a privilege to work beside the other hands-on staff who make museums tick, including librarians, receptionists, display staff, conservators, educators, and maintenance and security staff.

I thank the many museum staff who have assisted my research on museum objects by providing information or giving access to objects in their care. *The Bird Collectors* by Barbara and Richard Mearns was a tremendously helpful source of biographical information on historical figures connected to natural history museums. I thank Liz Clark for sharing information on Rajah's life before he arrived at Auckland, and the Fanua family for hospitality in Tonga.

I wish to acknowledge a contribution to the cost of my side trip to Florence—in search of the birds exchanged with Enrico Giglioli—from the bequest of the late Dora Blackie. I am grateful to Nigel Prickett and Tony Whitaker for helpful discussions on various points. I appreciate Mary Varnham's expert attention in improving my prose and I thank Mary and the other staff at Awa Press—Sarah Bennett, Fiona Kirkcaldie, Kylie Sutcliffe and Ruth Beran—for the transformation of the book from concept to reality. Views expressed in this book are my own personal opinions.

Index

A
Adams, Charles, 99–105
Africa, 21–22, 94
Aitutaki, 127, 132–33
Alastor (barque), 63
albatross, 51–55, 81
Alkrington Hall, 5
American Museum of Natural History (New York), 16, 55
American Ornithologists' Union, 70
ant, 29
Antarctic Research Expedition, *see* British, Australian, New Zealand Antarctic Research Expedition
archaeology, 15, 39, 124
Archey, Sir Gilbert, 14, 17
Argentina, 76
Arutanga, 127, 132
Asian house gecko, 128, 131–33
Asiatic elephant, 85
Auckland Acclimatisation Society, 93
Auckland Airport, 28, 116
Auckland Domain, 53, 93, 96, 105
Auckland Regional Council, 109
Auckland University, 114, 124
Auckland Zoo, 13, 85
Australia, 26, 28–29, 30, 33, 70, 76, 81, 131, 137
Australian Museum (Sydney), 135
Australian National Insect Collection (Canberra), 29

B
banded sea krait, 139
banjo frog, 107–10
Banks, Joseph, 5
Barea, Laurence, 119
barn owl, 26–31
Barrytown, 26
Beaumaris Zoo (Hobart), 86
Beccari, Odoardo, 66–67
beetles, *see* dermestid beetles
Bejakovich, Davor, 108–10
Bendire, Charles, 70
Bethlehem, 131
Bethune & Hunter (auctioneers), 35
biodiversity, 3, 11, 20, 23
biogeography, 129
black-thighed falconet, 65–66
bone collection, 10, 122
Borneo, 16, 102
Boulenger, George Albert, 19
Brighton, 37
Britain, 17, 36, 39, 44, 76, 90, 95, 101
British, Australian, New Zealand Antarctic Research Expedition (BANZARE), 15
British Empire Exhibition, 86
British Museum (London), 6, 12
British Museum (Natural History), 17–19, 39, 94

British North Borneo, 102
Brunei Revolt, 17
Bull's Head Inn, 6
Buller, Walter, 12, 35

C

cancer, 4
cane toad, 110
Canterbury Museum (Christchurch), 12, 14–15, 39, 48–49, 57, 68, 86, 102
Cape Horn, 36
Cape Kidnappers, 81
Cappel, Leo, 51, 54, 113
carpet viper, 21
Celebes, 68
Chatham Island taiko, 61
Chatham Islands, 58, 61
Cheeseman Hall, 57
Cheeseman, Emma, 59, 62
Cheeseman, Thomas, 14, 57–63, 66, 69, 94, 99–100, 102–104
Cheeseman, William Joseph, 57, 59, 62
chevron skink, 19
Chicago World Fair, 104
Chichester House, 37
China, 69
Clifford, Charles, 35
cold-water rotting, 123
Collett, Martin, 96
Colonial and Indian Exhibition, 38
Colonial Museum, Wellington, 102
common tern, 81
Comrade Lenin, 91
Conservation Genetics (journal), 46

Convention on the International Trade in Endangered Species (CITES), 116
Cook Islands, 127, 132
Cook, Capt. James, 6, 113–14
Coory, Raymond, 121
corn snake, 136
Coues, Elliott, 70
Crockett, David, 61
Cuvier Island, 100

D

Dannefaerd, Sigvard, 58
Darevsky, Ilya, 131
Dargaville, 53
Darwin, Charles, 116–17
de Filippi, Filippo, 60
Delaware Museum of Natural History, 72
Department of Conservation, 43, 109, 119, 122
dermestid beetles, 123
Dick, Philip K., 113
diorama, 51, 101
DNA, 9, 12, 22, 43, 45–46, 108, 116
Dominion Museum (Wellington), 15, 25, 38, 80
Doria, Marquis Giacomo, 67
dove, *see* spotted dove
Dover, Charles, 53, 86–88
du Pont, John Eleuthère, 72
Duke of Genoa (Prince Tommaso of Savoy), 65–66

E

East Australian Current, 120
Edward Gerrard & Sons, 94

elephant, *see* Asiatic elephant
elephant bird, 33

F
Faddie, James, 36
falconet, *see* black-thighed falconet
Falla, Sir Robert, 15, 25, 38
Feilner, Sgt. John, 71
Fergusson, Sir Bernard, 115
fernbird, 18
Fiji, 110, 132
Fiji Airways, 117
Finland, 81
Flat Point, 122
Florence, 60, 66
Forbes, Anna, 68
Forbes, Henry, 68
Fortey, Richard, 3
Foster Bay, 136
fox gecko, 129–30
Freyberg, Lady, 57
frog, *see* banjo frog
Fyffe House, 39
Fyffe, George, 34, 35, 37

G
Galápagos Islands, 104, 116–17
Galsworthy, Sir Arthur, 54
gannet, 81
gecko, *see* Asian house gecko, fox gecko, oceanic gecko, sad gecko *and* stump-toed gecko
giant moa, 22–23, 33, 41
Giglioli, Enrico, 60, 66
Goldie, Andrew, 67
Grant-Mackie, Jack, 124
Gray, John Edward, 12

green turtle, 120–121, 125
Greenock, 53
Griffin, Louis, 57
Gross, Richard Oliver, 57
Günther, Albert, 12

H
Haast River, 25
Hall, Martin, 21
Handbook of Australian, New Zealand and Antarctic Birds, 21
Harrisson, Tom, 16
Hawaii, 132
Hawkins, W., 58
hawksbill turtle, 120–21
heavy-footed moa, 40
Hen and Chickens Islands, 54
Henshaw, Henry, 70
heron, *see* reef heron
Hewitt, Capt. Vivian, 38
Hickman, Gary, 119
Hill, Jane, 124
Hinton, Martin, 18
Hokianga, 137
holotype, 47
Hong Kong, 60
hornero, 76
hospital ship, 53
house mouse, 29
Hunstein, Carl, 67
Hutton, Frederick, 57

I
Illinois State Laboratory of Natural History, 104
India, 97
Inglis, Capt. D.B., 36

International Code of Zoological Nomenclature, 46
International Commission on Zoological Nomenclature, 47
International Dateline Hotel, 115, 117
Isle of Wight, 5
Italian Entomological Society, 60

J
Jakob-Hoff, Richard, 13
James, E.G., 38
Jammit, 43, 49
Jamuna, 85–86
jellyfish, 83
Johnston, Maree, 122, 124

K
Kaikoura, 34, 39
Kaikoura Museum, 39
Kaitaia, 30
Kaka Point, 122
Karewa Island, 100
kea, 71, 101
Keesing, Rose, 61
King of Tonga, 113, 117
Kinsky, Fred, 16
kiwi, 43–46, 48–49

L
leathery turtle, 120
Leiden, 47
Leningrad Academy of Sciences, 131
Lever, Sir Ashton, 5–6
Libya, 21
Linnaeus, Carl, 46
Little Barrier Island, 54

loggerhead turtle, 120–22
London, 5, 7, 12–13, 20–21, 36, 38, 60, 69, 85, 94, 125, 135
lottery, 6
Louis XIV, 6

M
Mackechnie, Edmund Augustus, 93
Madagascar, 33, 114, 117
Magenta (warship), 60
Magenta petrel, 61
Malacca, 65–66
Malay Peninsula, 65
Malaya, 17
Mao Zedong, 91
Māori cultural group, 90
Marama (steam ship), 53
Mariposa (steam ship), 102
Mauritius, 116
Mawson, Douglas, 15
Mayr, Ernst, 16
Melbourne, 102
Mexico, 132
mihirung, 33
Milford Sound, 102
Ministry of Agriculture and Forestry, 108, 111
moa, *see* giant moa *and* heavy-footed moa
moa egg, 35–41
Montagu House, 6
Morcott Hall, 38
Moriori, 61
mouse, *see* house mouse
Museo Civico di Storia Naturale (Genoa), 66
Museo Zoologico e di Storia Naturale (Florence), 62

Muséum national d'Histoire naturelle (Paris), 7
Museum of Comparative Zoology (Harvard), 16
Museum of New Zealand Te Papa Tongarewa, 40, 80, 121, *see also* National Museum of New Zealand
Museum of Victoria, 88
musk ox, 94
myna, 79

N
National Geographic Society, 117
National Museum of New Zealand, 16, 80, 88, *see also* Museum of New Zealand Te Papa Tongarewa
Natural History Museum (London), 7, 17, 20–21
Nature (journal), 22, 37
Nelson, Edward, 70
New Britain, 67
New Guinea, 16, 66, 131
New York, 55, 100
New Zealand Army, 63
New Zealand Exhibition (Dunedin), 35
New Zealand House, 38
New Zealand Listener, 48
New Zealand Meteorological Service, 29
New Zealand National Banding Scheme, 80
Nigeria, 21
nomen nudum, 48
North Brother Island, 12

O
oceanic gecko, 129
Ōkārito, 43, 45
Okura, 25
olive ridley turtle, 121–22
Orakei Basin, 62
orang-utan, 99, 103–105
Ornithological Society of New Zealand, 48
Otago Museum, 1, 2, 40, 102
Outback, 30
ovenbird, 75
Owen, Sir Richard, 37
owl, *see* barn owl
ox, *see* musk ox
Oxford University Press, 21

P
Palais du Louvre, 6
Papatoetoe, 27, 30
parthenogenesis, 130
Pernambuco, 36
Pirongia, 100
Pitcairn Island, 60
plover, *see* spur-winged plover
polar bear, 94
Polynesian voyagers, 129–30
Port Chalmers, 102
Port Moresby, 67
postage stamp, 72, 139
Prasad, Ramola, 123
Pratt, R.A., 38
Prince Philip, 115

Q
Queen Elizabeth, 115
Queen Sālote, 115

R

rainbow skink, 111
Rajah (elephant), 85–91
Rarotonga, 132
Ravenscraig (ship), 36
reef heron, 57, 62
Regent Palace Hotel, 38
Reischek, Andreas, 86
Reparoa, 81
Ridgway, Robert, 70
Riedel, J.G.F., 68
Robb, Joan, 114
Roosevelt, Theodore, 71
Rowley, G.T., 38
Rowley, George Dawson, 37
Royal Australasian Ornithologists' Union, 21
Royal College of Surgeons, 125
Royal New Zealand Air Force, 54
Ruby (schooner), 35
Runanga, 26
Rutherford, Ernest, 3

S

sad gecko, 129–30, 132
Saint Helena, 116
Salvadori, Tommaso, 61, 66
Samoa, 72, 129
Samoan triller, 18
Sandakan, 103, 105
Sandström, George, 72
Sarawak Museum, 16
Scarlett, Ron, 14
Schultz, David, 72
screwworm fly, 22
sea snake, 135–39
Seebohm, Henry, 68
Shag River Mouth, 40
Sharpe, Richard Bowdler, 17
Shaw Savill Line, 95
shearwater, 101
Sheffield, Rev. William, 5
Shufeldt, Robert, 71
Siberia, 68
Simmons, Dave, 18
Singapore, 66
skink, *see* rainbow skink *and* three-toed skink
skua, 51–52
Sloane, Sir Hans, 6
Smithson, James, 14
Smithsonian Institution (Washington, D.C.), 14, 39, 69, 121
Smyth, William, 59
snake, *see* corn snake
Society Islands, 132
Solomon Islands, 16
South America, 75
sparrow, 70, 81
spectrophotometer, 9
spotted dove, 78–79
spur-winged plover, 78–79
St Clair Beach (Dunedin), 1
starling, 79
Steven's Rooms (Covent Garden), 37
stump-toed gecko, 129–30, 132–3
swallow, *see* welcome swallow
Sweden, 47
Swinhoe, Robert, 69
Systema Naturae (Linnaeus), 47

T

tadpole, 107–10
Taiaroa Head, 81
Tasman Sea, 26, 120
Tasmania, 85
Tasmanian tiger, 86
taxidermy, 7, 30, 49, 53, 59, 86, 88, 94, 99, 104
taxonomist, 3
Te Papa Tongarewa, *see* National Museum of New Zealand *and* Museum of New Zealand Te Papa Tongarewa
tern, *see* common tern
Three Kings Islands, 61
three-toed skink, 4
tiger, 96
Tizard, Dame Catherine, 90
toad, *see* cane toad
Tokerau Beach, 138
Tonga, 113–17, 129
Tongan National Centre, 115, 117
Tongatapu, 114
torpor, 30
Tradescant, John, 5
Tradescant's Ark, 5
Transactions & Proceedings of the New Zealand Institute (journal), 60
tsunami, 67
Tu'i Malila, 113–17
tuatara, 12–13, 101
Turbott, Graham, 27, 102
turtle, *see* hawksbill turtle, leathery turtle *and* olive ridley turtle
Tyler, Michael, 108–109

U

Union Steamship Company, 53
United Nations, 22
United States Army, 70
United States of America, 7, 11, 81, 101, 103
University of Illinois, 100
Upper Hutt, 81

V

Vanuatu, 17, 132
Vettor Pisani (corvette), 66
Violani, Carlo, 65
von Haast, Julius, 57

W

Waikorea Beach, 119
Ward, Henry Augustus, 100
Washington Biological Survey, 81
Washington, D.C., 14
Weatherley, David, 55, 90
welcome swallow, 78
Wellington, 25, 35–36, 39–40
Westland, 25, 43
Whangarei, 124
Whatipu, 109
Whitaker, Tony, 109–10, 133
Whitehead, Peter, 19
Whitney South Sea Expedition, 16
Wise, Keith, 29

Y

Year of the Snake, 139
yellow-bellied sea snake, 136–39